Springfield

Springfield

*To Simon Gregory
Hope you enjoy this
souvenir of your trip
to our city*

*Thanks for your
service*

G. Michael Dobbs

ARCADIA
PUBLISHING

Published by Arcadia Publishing
Charleston, South Carolina

Printed in the United States of America

Library of Congress Catalog Card Number: 2008920518

For all general information contact Arcadia Publishing at:
Telephone 843-853-2070
Fax 843-853-0044
E-mail sales@arcadiapublishing.com
For customer service and orders:
Toll-Free 1-888-313-2665

Visit us on the Internet at www.arcadiapublishing.com

For Noel, our first granddaughter and born in Springfield.

CONTENTS

ACKNOWLEDGMENTS

This book could not have been possible without the upbringing I had by parents who loved history and art and exposed me to both with many trips to museums around the country.

Nor could it have been possible without support of my wife Mary.

I would like to thank Margaret Humberston of the Connecticut Valley Historical Museum and her colleagues and Springfield historians Robert Walker and James Boone for their help and patience.

This book is meant to be an introduction of a great American city. There are a number of books that explore the story of Springfield much more deeply, and I recommend *Springfield 1636–1986*, edited by Michael F. Konig and Martin Kaufman; *At the Crossroad Springfield, Massachusetts 1636–1975*, by Frank Bauer; and *Springfield - 350 years: A Pictorial History*, by Donald J. D'Amato.

To learn more about Springfield's historic buildings that define the character of the city, go to the Web site of the Springfield Preservation Trust at www.springfieldpreservationtrust.org.

Naturally I also would like to tip my hat to Erin M. Rocha, my editor at Arcadia Publishing for her assistance.

INTRODUCTION

For many people, Springfield is the name of the Simpsons' hometown in the popular animated series. For those who know a little about the history of this country, Springfield has a different meaning.

Springfield, Massachusetts, the oldest and largest city with that name, is known as the "City of Firsts" for a reason—actually many reasons.

Springfield is where basketball was invented. It is where the Duryea brothers built and tested the first American gasoline-powered car. It is the community where the first and perhaps most beloved American motocycle—they spelled it without the *r*—the Indian was developed and manufactured.

It is the city where the first American armory was built and where the Springfield Rifle was made.

And it was the insurrection by Revolutionary War veterans led by Daniel Shays on that armory that led to the creation of the United States Constitution.

Clarence Birdseye chose Springfield as his test market in the 1930s for something truly radical: frozen vegetables.

A group of brothers, the Granvilles, literally off the farm, picked Springfield to be their headquarters in the 1920s and 1930s, where they would design and build the GeeBee racing planes that still awe aviation enthusiasts.

The city was the home of Milton Bradley, who revolutionized the toy industry with board games. The city's streets, schools, and parks gave hometown boy Theodor Geisel, better known as Dr. Seuss, inspiration for later books and illustrations.

All these accomplishments happened at a place where an English businessman named William Pynchon, the founder of Springfield, sensed potential in the mid-1600s.

According to historian Ernest Newton Bagg, Pynchon, who was a patentee and magistrate to the Massachusetts Bay Colony, was attracted to the Connecticut River Valley as a place rich with fur animals, especially beaver.

After a long voyage from England in 1630, Pynchon began trading goods that he had brought from England with native people for furs. What attracted him to western Massachusetts was the possible encroachment of Dutch traders who had established a trading post along the Connecticut River in what is now Hartford, Connecticut.

Some of the Dutch traders even came to Springfield, but disease and hunger compelled them back to the relative safety of the Hartford establishment.

Pynchon wanted to succeed where the Dutch had failed and began planning an effort to build a settlement in what is now Springfield in 1635.

Using a shallop, a light single-mast vessel, Pynchon and his expedition sailed up the Connecticut River. He made a camp in what is now West Springfield, and his men used the boat's lumber for their new home.

The native people seemed friendly, and Pynchon was impressed with the virgin forests with large and small game, a river teeming with shad and salmon, and lands ready for agriculture.

Pynchon left his men and returned to the settlement of Roxbury by foot. When he returned the next spring, he was told the relationship between the natives and Pynchon's men had deteriorated, and Pynchon was forced to move his operation to the eastern side of the river.

Despite the problems, caused in part by the damage to the natives' cornfields by the settler's free-range hogs, Pynchon was able to come to an agreement on July 15, 1636, to acquire the desired Agawam land. Further negotiations gave him the control of an area from the Chicopee River to the Mill River.

Trouble with crops, a narrowly averted war with the native people, and even an earthquake were some of the challenges early settlers faced. Pynchon was right, though, about the richness of the area for furs. Bagg noted in his 1936 history of Springfield that although there was no record of just how well Pynchon fared during his 15 years of trading furs in the area, his son John continued the business after his father returned to England and regularly shipped 2,000 beaver skins annually to merchants in his native country.

Pynchon has the additional distinction of being the author of the first book "banned in Boston." His 1650 book, *The Meritorious Price of a Man's Redemption*, took exception to Puritan theology. The colony's general court condemned the book, and copies were burned on Boston Common.

Pynchon was under great pressure to recant, and after one appearance before the court, he decided to transfer all his holdings to his son John and return to England before he was forced to appear before the general court once more. He left the colony in 1652. His death at age 72 in 1662 closed the first chapter in the city's history.

Pynchon's legacy was that his purchase of land did not just create one community, Springfield, but the following towns and cities as well: Agawam, Chicopee, East Longmeadow, Hampden, Holyoke, Longmeadow, Ludlow, Southwick, Westfield, West Springfield, and Wilbraham, as well as Enfield and Suffield, Connecticut.

No less a person than Gen. George Washington had a hand in the next major development of the community. In February 1777, Washington authorized an "establishment of the laboratory at Springfield."

The Springfield Armory became known as a center for technological innovation in manufacturing and undoubtedly led to Springfield becoming a center for skilled manufacturing.

Another famous gun maker, Smith & Wesson, made the city its home and is still in business today.

Early in its history, the Springfield Armory attracted the attention of a group of farmers enraged at the taxation tactics of the Massachusetts state government. In February 1787, as the culmination of a series of armed protests started the previous year, Daniel Shays, Revolutionary War veteran and farmer from Pelham, led a group of men to capture the Springfield Armory. Although Shays failed at the armory, his protest succeeded in showing the weakness of the Articles of Confederation, and in May 1787, the Constitutional Convention was convened to reshape federal government.

Previous to the attack on the Springfield Armory, Thomas Jefferson expressed his reaction to Shays' Rebellion in a letter to James Madison on January 30, 1787. Jefferson wrote,

I hold it that a little rebellion now and then is a good thing, and as necessary in the political world as storms in the physical. Unsuccessful rebellions, indeed, generally establish the encroachments on the rights of the people, which have produced them. An observation of this truth should render honest republican governors so mild in their punishment of rebellions as not to discourage them too much. It is a medicine necessary for the sound health of government.

The Springfield Armory inspired another kind of reaction from American poet Henry Wadsworth Longfellow. Longfellow and his second wife, Frances, visited Springfield and the Springfield Armory in 1845. The tour inspired what was considered to be Longfellow's most effective antiwar poem, "The Arsenal at Springfield." The first two stanzas read, "This is the Arsenal. From floor to ceiling, / Like a huge organ, rise the burnished arms; / But from their silent pipes no anthem, pealing / Startles the villages with strange alarms. / Ah! What a sound will rise, how wild and drear, / When the death-angel touches those swift keys! / What a loud lament and dismal Miserere / Will mingle with their awful symphonies!"

In the book *Springfield Memories*, published in 1876, Mason Green wrote about the development of the city:

> Modern Springfield was born with the peace of the war of 1812. In the reaction from embargoes and war from 1814 to 1825 there was a general housecleaning and business re-adjustment. The old tavern site was cleared off for a Common, a church and court-house was built by the side of it and another church (Unitarian) down Main Street, Union and Court Streets were opened, the river bridge, that was swept away by a flood was restored (1818), a line of boats was established between the village and Hartford, connecting with Boston and New York schooners, neighboring water powers were utilized, many mechanics and artisans were called in, who became residents, and the Weekly Springfield Republican was started, which insured the place a future.

In 1936, when the city was celebrating its 300th anniversary, the unaccredited author of one of the commemorative booklets wrote,

> Varied are the products of Greater Springfield: Intricate machines, radios and electrical appliances, tires, motorcycles, garments, arms, games and school materials, books and magazines, newspapers, wire, chains, machine tools, cigars, chemicals and medicines, valves, oil pumps, fine paper, jute boxes, clocks and leather goods. Here once were the pioneers in the manufacture of automobiles. Across the river are the railroad shops.

The first American-made gasoline-powered car was built and tested in Springfield by Charles and Frank Duryea on September 20, 1893. The city would later be the site for a factory producing Duryea cars.

The Knox Automobile Company produced cars and the first fire engines from 1900 to 1914 in Springfield and stayed in business with tractors until 1924. And Rolls Royce picked the city as the site for its only American automobile manufacturing plant. The Springfield Rolls Royce facility opened in 1920 and closed in 1931; collectors prize the cars made here.

Also still highly prized are the Indian Motocycles made in the city from 1901 to 1954. The brainchild of engineer Oscar Hedstrom, the "motocycles" were the first ones made in this country and were well known for their power and durability.

Brought to the city by bicycle racer and manufacturer George Hendee, Hedstrom developed a motorcycle that he tested publicly on May 25, 1901, on the Cross Street hill downtown. Newspaper reporter R. D. Pepin wrote about the test on its 25th anniversary: "Hedstrom bravely climbed the old hill and forcefully demonstrated to the residents of Springfield the first step towards an industry destined to fill a long place in the field of industry, utility and sport."

Pepin noted that Hendee had featured motor-drive bicycles made in Europe at his bicycle-racing track. "The uncertainty of these motors was a source of great anxiety to the management and of dissatisfaction to the patrons of the track," Pepin wrote.

With Springfield a growing center of transportation technology, it is little wonder that a group of brothers left the family farm to come to Springfield and pursue their dream of developing faster and more powerful airplanes. Although the Granville brothers were in business for only five years, from 1929 to 1934, and built just 24 aircraft, their revolutionary designs created a legend among aviators.

Springfield was also a city of ideas as well as industry and technology. Abolitionist John Brown made the city his headquarters in 1846 when he established a business to represent wool producers to the New England mill owners. Later the city was a stop on the Underground Railroad.

G and C Merriam Company was founded in 1831 as printers and booksellers, and the pair of brothers purchased the rights to the name and all copyrights to the best-seller dictionary written by Noah Webster in 1843. Since that time, the nation's best-known reference book has been written and published in Springfield.

When stumped about how to excite his winter physical fitness class, a young Canadian attending the International YMCA Training School remembered Duck on a Rock, a game from his youth. Taking a soccer ball and a peach basket, James Naismith developed the game of basketball in 1891, quite possibly the most popular indoor sport.

The Naismith Memorial Basketball Hall of Fame draws over 250,000 visitors a year to its Springfield shrine to the game.

A number of people prominent in show business and the arts are natives of the city.

During the 1920s and 1930s, Broadway and radio star Julia Sanderson was a popular performer. Sanderson was a hometown girl who made good and for a period in the 1970s and 1980s was remembered when the former Paramount Theater downtown was renamed the Sanderson in her honor.

The classic movie musicals *Born to Dance* and *Broadway Melody of 1940* were just two of the movies that featured another Springfield native, Eleanor Powell. The beautiful and athletic dancer was a star at MGM. She was married to actor Glenn Ford for a number of years, and by the end of her life, she turned her energies to religion.

Lawrence O'Brien, a Kennedy family supporter, postmaster general, head of the Democratic Party, and commissioner of the National Basketball Association, was another Springfield resident. His father had a tavern where the Mass Mutual Center now stands, and he received his law degree from Western New England College.

Perhaps the most interesting favorite daughter is June Foray, whose family left their home on Orange Street and traveled to California, where she eventually became one of the most highly regarded voice actresses in animation, providing the voice for Rocky in *Rocky and Bullwinkle*, Granny in the Tweety Bird cartoons, and many other characters.

In the 1980s, students at the former Classical High School could still find evidence of that school's most controversial graduate, Dr. Timothy Leary. His name could be seen carved into at least one desk. Leary was one of the prominent leaders of the counterculture in the 1960s and urged people to "turn on, tune in, and drop out."

Springfield's most beloved native is Theodor Geisel, better known to generations of Americans as Dr. Seuss. The author and illustrator took inspiration from the city of his birth, from the names of streets (such as *And to Think that I Saw it on Mulberry Street*) to his father's position as superintendent of the city's parks (seen in *If I Ran the Zoo*). The Dr. Seuss National Memorial Sculpture Garden at the Springfield Museum complex pays tribute to the innovative storyteller.

Springfield's latest burst of national publicity came in 2007 with a contest that asked fans of *The Simpsons* to pick the Springfield that is actually home to the best-known dysfunctional family. Although Springfield, Massachusetts, did not win in a surprising upset to Springfield, Vermont, the producers of the animated series and film knew better. They had prepared a special poster before the contest's final results that declared the movie was filmed in Springfield, Massachusetts.

A community of rich diversity and history, Springfield today is the home of national companies, three colleges, and a law school. It was named the fourth "greenest" city in the nation and was recognized as one of the greatest centers of small business and entrepreneurship in the country. Its best days are not behind it.

One

BEGINNINGS

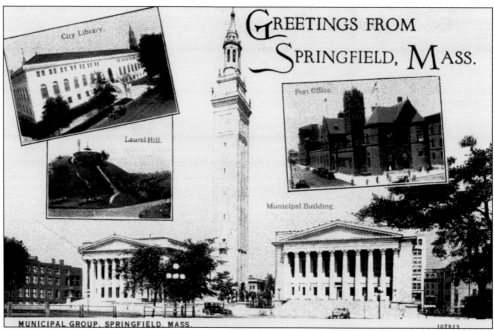

It is safe to say that William Pynchon would not recognize the fur-trading outpost that he founded if he visited the city when this postcard was produced in the 1920s. By the mid-19th century, the city had come into its own as a rail terminus and industrial center. By the mid-20th century, it had become the unofficial capital of western Massachusetts.

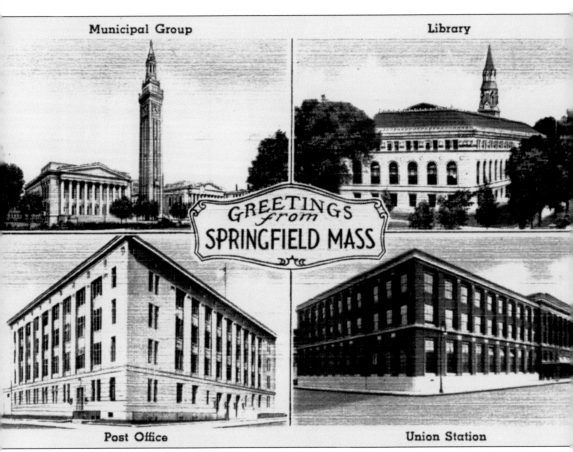

Municipal Group Library

GREETINGS *from* SPRINGFIELD MASS

Post Office Union Station

By the 1940s, Springfield had become a city of institutions and nationally known manufacturers.

With Forest Park as a major regional destination point as well as the train station that served thousands of travelers each day, Springfield was a well-known community in the Northeast.

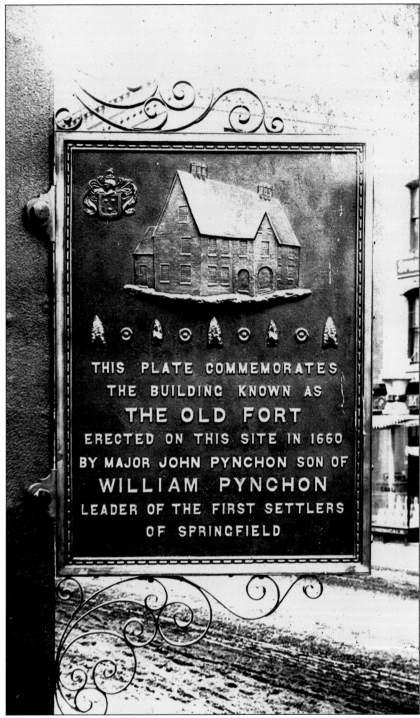

This plaque marked the location of the fort built by William Pynchon, the founder of Springfield. While it is no longer attached to any building, a contemporary historical marker is located outside the door of the Student Prince/Fort restaurant on Fort Street in downtown Springfield. (Courtesy of Robert Walker.)

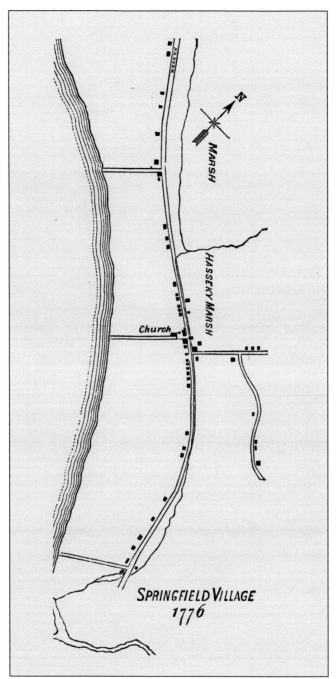

The book *Springfield Memories*, published in 1876, presented this map of how the village looked at the time of the Revolutionary War. Author Mason A. Green wrote, "The visitor to the village of Springfield in 1776 standing at the corner of Main Street and Ferry Lane (Cypress Street) —at that time the business center—would have in view, down the west side of the street, most of its 175 houses and the solitary church spire, with pasture land running back to the river. On the east side were a mountain brook, a narrow strip of wet grass land ('hasseky marsh')—as often a pond as a meadow—and an elm and oak-fringed forest of pine raising on a broad plateau."

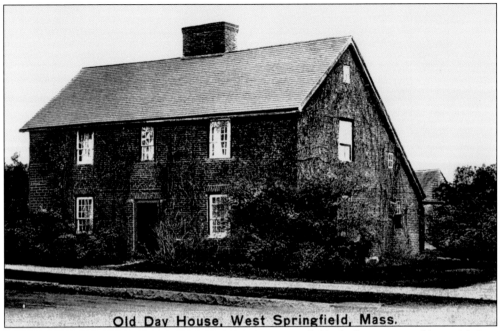

Old Day House, West Springfield, Mass.

While few Colonial-era buildings remain in today's Springfield, the home erected by Josiah Day in 1754, then considered to be in Springfield although it is now in West Springfield, still stands. This saltbox remained in the Day family until 1902, when it was bought by the Ramapogue Historical Society and preserved as a museum.

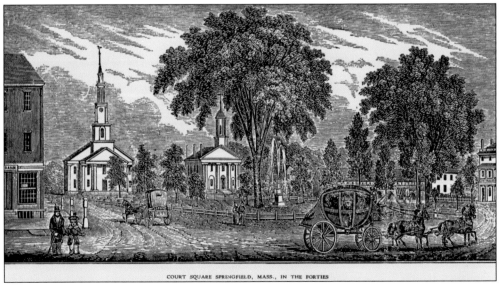

COURT SQUARE SPRINGFIELD, MASS., IN THE FORTIES

This woodcut shows Court Square in the 1840s. The Old First Church is seen at the left with the first courthouse next to it.

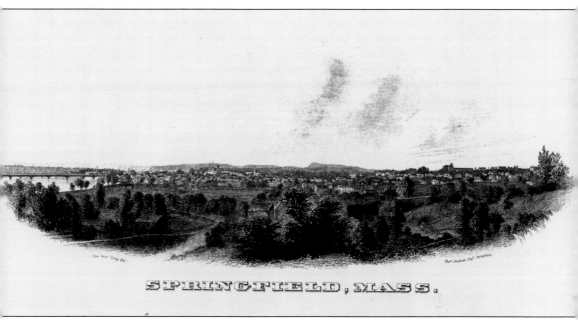

SPRINGFIELD, MASS.

This engraving of Springfield in 1876 shows the now-growing city in the background but reveals its bucolic nature. For some time in the 1970s—a century since the time of this image—Springfield was marketed with the slogan "the city in the country."

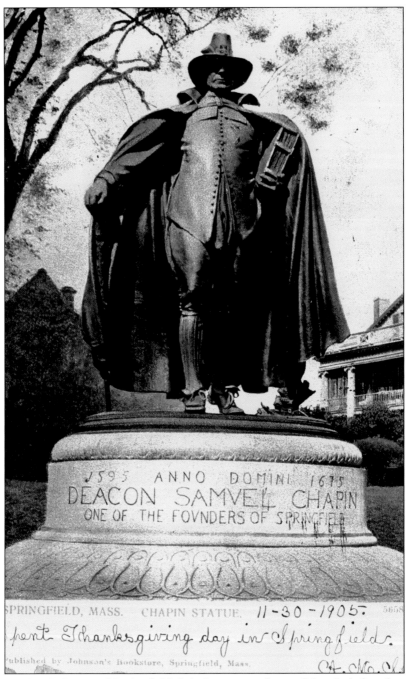

1595 ANNO DOMINI 1675
DEACON SAMVEL CHAPIN
ONE OF THE FOVNDERS OF SPRINGFIELD

SPRINGFIELD, MASS. CHAPIN STATUE. 11-30-1905. 5658

spent Thanksgiving day in Springfield.

Published by Johnson's Bookstore, Springfield, Mass. *A. Mc. Cl.*

If there is an iconic image of Springfield, it is the statue of one of the city's founders, Deacon Samuel Chapin, by Augustus Saint-Gaudens that now sits in Merrick Park next to the Central Library on State Street. The statue, known as the *Puritan*, was completed in 1887. Descendant Chester Chapin commissioned Saint-Gaudens in 1881, and the statue was originally located in Stearns Square in a site designed by Stanford White. Saint-Gaudens wrote that more than just portraying an image of a single person, he wanted the statue to convey the characteristics of the people who settled Massachusetts.

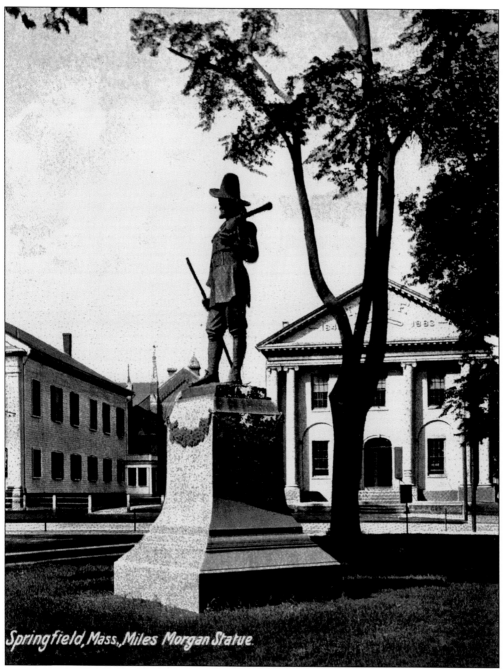

Springfield, Mass., Miles Morgan Statue.

Another statue of a prominent early settler can be seen in Court Square. Miles Morgan was William Pynchon's second in command in the expedition that founded the city. Morgan was remembered as a romantic figure who fell in love with a young woman he saw on the docks of Bristol, England, who was coming to the colonies with her family. He subsequently came to Massachusetts, joined the Pynchon party, received a parcel of land, and then set out to win the hand of his beloved.

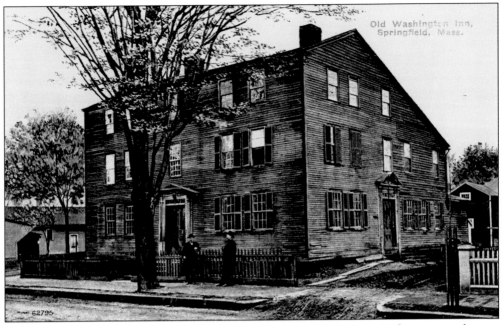

This postcard is identified as "Old Washington Inn," but the building is the same as the one known as Parson's Tavern, which was located in Court Square. George Washington did spend a night there in 1789, and perhaps that explains the name change. This 1881 image shows the inn at its second location behind Old First Church.

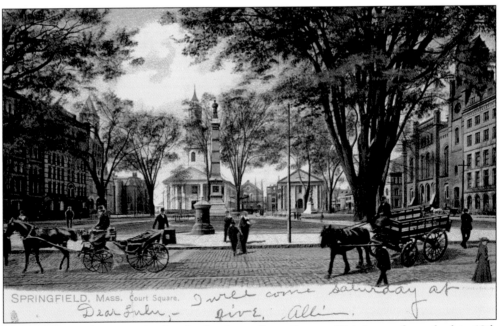

The architectural constant in the city has been Court Square. This image from the late 19th century shows a trolley track, but no electrical lines have been installed as yet. The Old First Church and old courthouse can be seen in the background, and city hall is at the right of the image. To the far left is the Court Square Hotel.

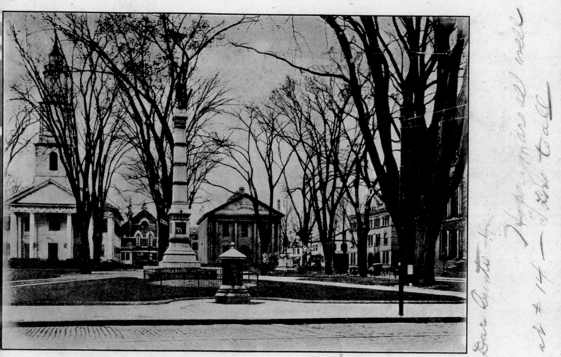

No. 13 Court Square, Springfield, Mass.

The Old First Church (left in the image) was erected in 1819 and was the fourth and final church constructed on the same location. The first church was built there in 1637 and was the oldest church in western Massachusetts. A second building in 1752 succeeded it. The church was closed in 2007 when the congregation had become too small to support it. The City of Springfield bought the structure to preserve it.

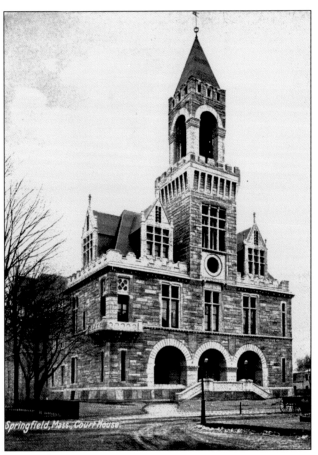

Springfield, Mass. Court House.

A new Hampden County courthouse was built across from the Old First Church and stands today used as a juvenile courthouse. The stone building was originally built with dormers that were removed, as shown in an image postmarked 1935.

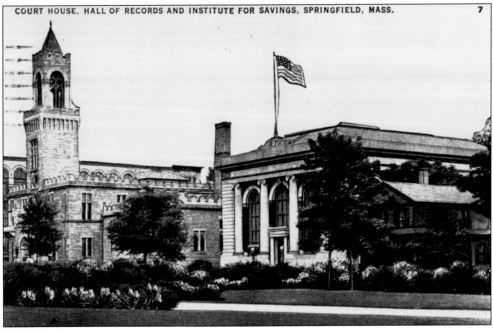

COURT HOUSE, HALL OF RECORDS AND INSTITUTE FOR SAVINGS, SPRINGFIELD, MASS. 7

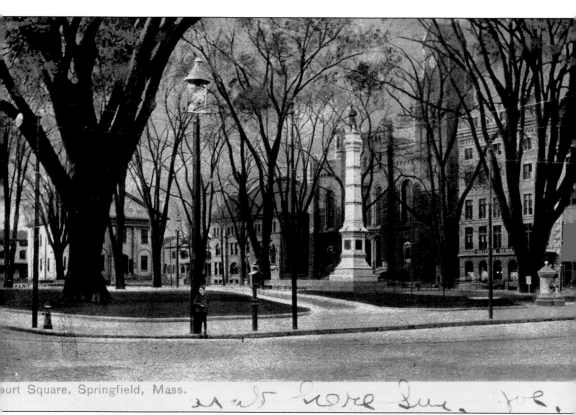

urt Square, Springfield, Mass.

The second town hall for Springfield can be seen behind the Civil War monument covered in ivy. Built in 1854, it replaced the city's first town hall that was built in 1828. Springfield had been incorporated as a city in 1852, and the second structure not only housed government offices but the police department as well.

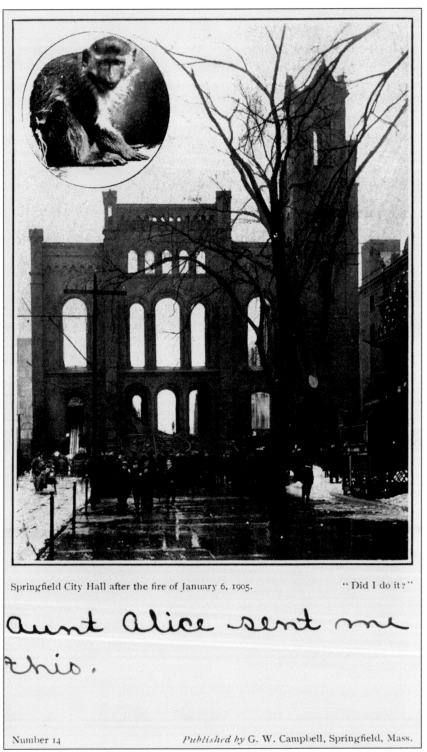

Springfield City Hall after the fire of January 6, 1905. "Did I do it?"

aunt Alice sent me this.

Number 14 *Published by* G. W. Campbell, Springfield, Mass.

The town hall was destroyed by fire on January 6, 1905, supposedly by a monkey that overturned a lantern.

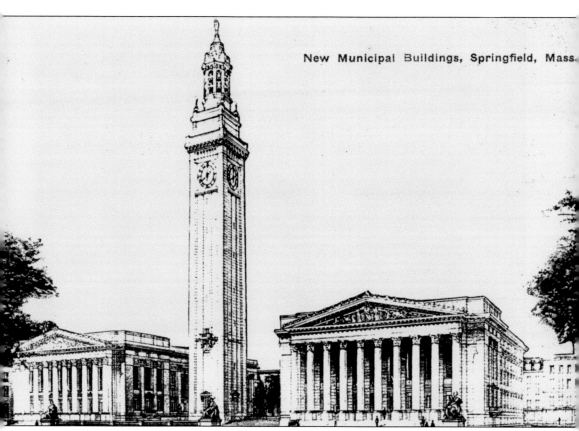

The planning, design, and construction of the new Municipal Group took seven years, and the three new structures—the Auditorium, the Campanile, and city hall—were dedicated on December 8 and 9, 1913. This postcard is actually an architectural rendering of the buildings. There were no large statues installed as pictured.

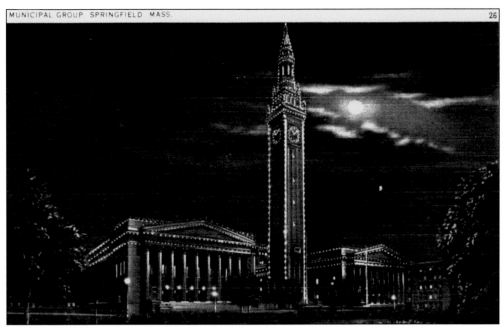

MUNICIPAL GROUP AND ADMINISTRATION BUILDING.

Springfield residents were proud of their new municipal complex, and this postcard shows a fanciful representation of the buildings at night.

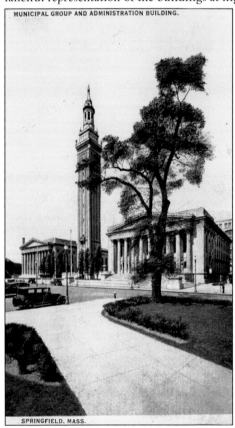

SPRINGFIELD, MASS.

The buildings were made of steel and reinforced concrete with Indian limestone on the exterior. In a 1936 commemorative booklet, the Municipal Group was described as "the outward evidence of the spirit of hospitality which is demonstrated to all of our visitors."

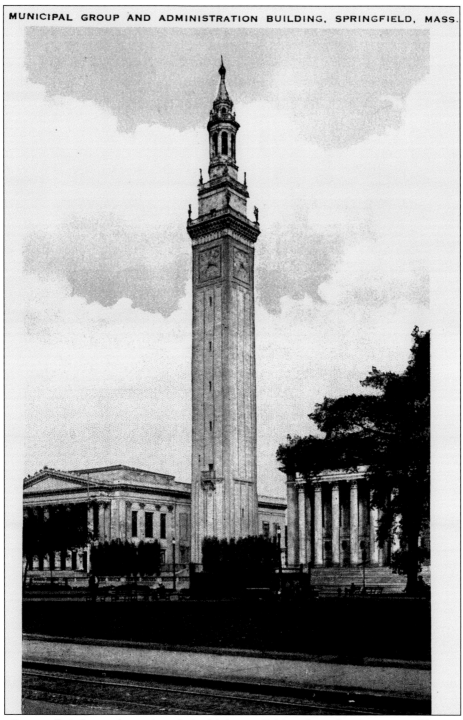

The Campanile is featured prominently in this image. Rising above the city, one could see points including Talcott Mountain in West Hartford, Connecticut, Kidd's Lookout in Chesterfield, and Lincoln Mountain in Pelham. The tower's chime consisted of 12 bells that were played by a keyboard.

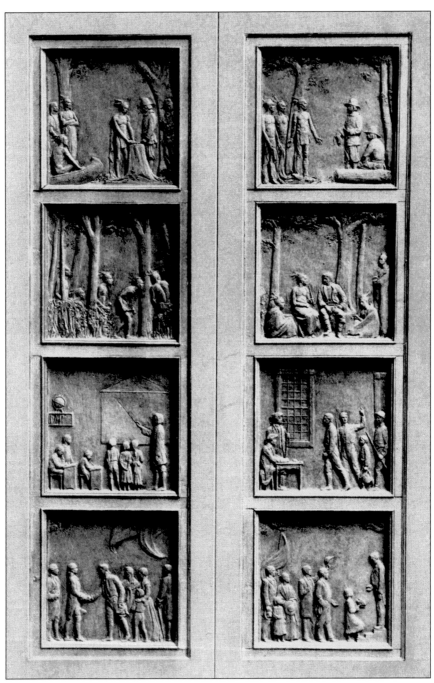

The doors of the Auditorium and city hall both have bronze doors that depict a number of key points from the city's history. The Auditorium doors are seen here. The panels on the left, from top to bottom, show the buying of the lands that formed Springfield in 1636; the burning of Springfield in 1675; the first public school in 1709; and the 1817 visit of Pres. James Monroe. The second group of panels (right side) shows, from top to bottom, trading with the Native Americans in 1640; Maj. John Pynchon in 1685; the Springfield minutemen in 1775; and when Springfield became a city in 1852, with people gathering to honor the first mayor, Caleb Rice.

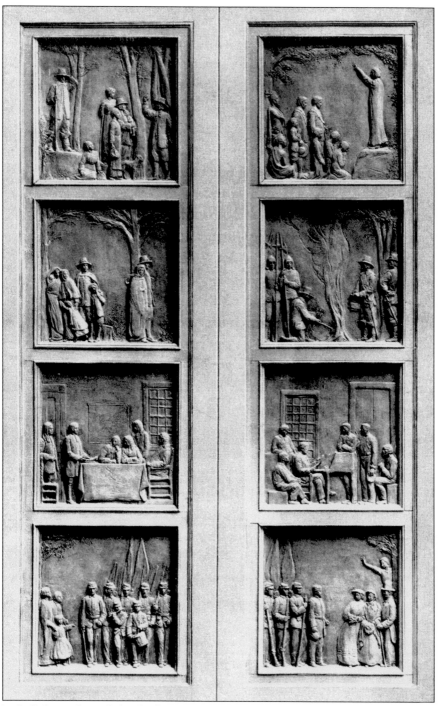

The city hall doors show (left side, from top to bottom) William Pynchon and the settlers from Roxbury en route to Springfield in 1636; the town's witchcraft superstition in 1648; the Breck controversy in 1735; and townspeople marching away to war in 1861. The second set (right side, from top to bottom) includes the first preaching in 1637; the burning of Pynchon's book in 1650; an appearance by abolitionist John Brown; and the troops returning from war.

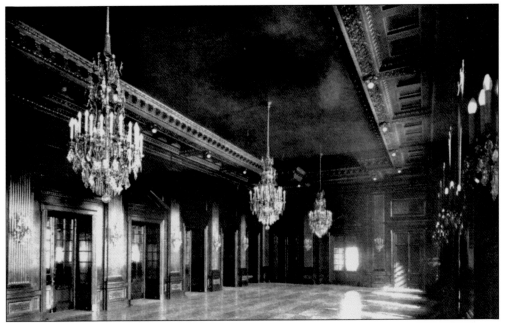

The Mahogany Room of the Auditorium was designed as a venue for events following performances in the Auditorium. The room has changed little since this photograph was taken in 1936 as part of the city's 300th anniversary celebration.

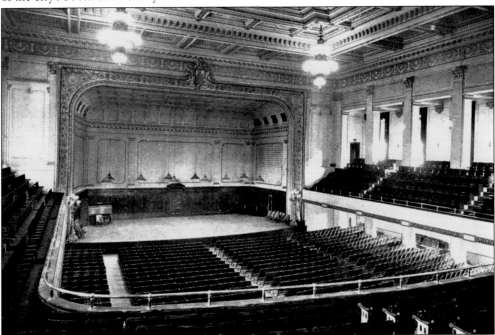

The Auditorium was designed to seat 4,000 people, and although it has undergone renovations to preserve its original design and acoustics, more modern seating has reduced its capacity to 2,611. On March 5, 1944, the Springfield Symphony performed its first concert and became the primary tenant in the building. The symphony is so identified with the building that most people call the building Symphony Hall.

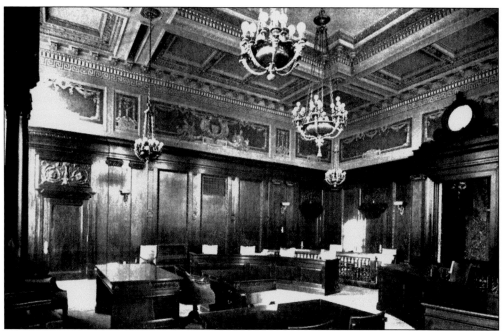

The new city hall featured separate rooms to house the two parts of the city council. The Aldermanic Chamber housed the group of councilors elected at large, while the Common Council Chamber was where the councilor elected by ward met. Both rooms were appointed with wood panels, ornate ceilings, and chandeliers. Today the rooms look essentially the same as they did in these photographs from 1936. The Common Council Chamber is used by today's city council, while the Aldermanic Chambers are used by a variety of city bodies, including the school committee.

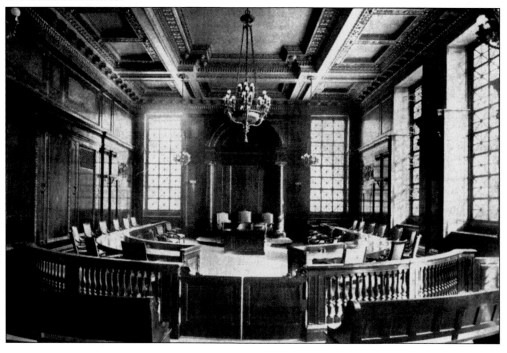

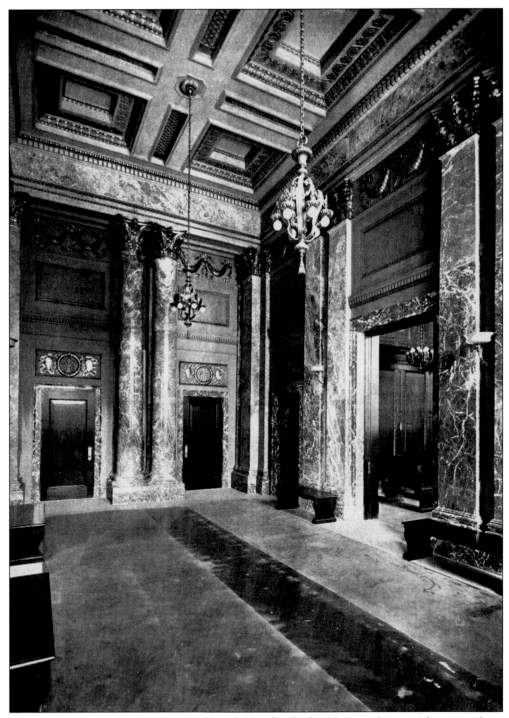

The second-floor corridor is a secondary lobby for the building as this corridor runs along the entrance to the City Council Chamber. The interiors of city hall feature 27 varieties of marble.

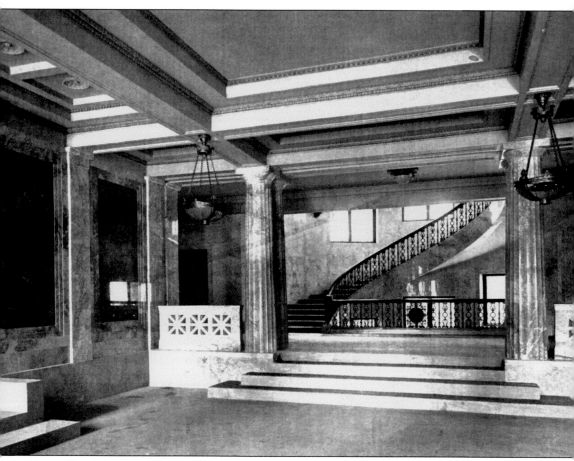

Great effort has been made over the years to maintain the original look of city hall. In the main lobby, the only real difference is that portraits of mayors hang on the walls.

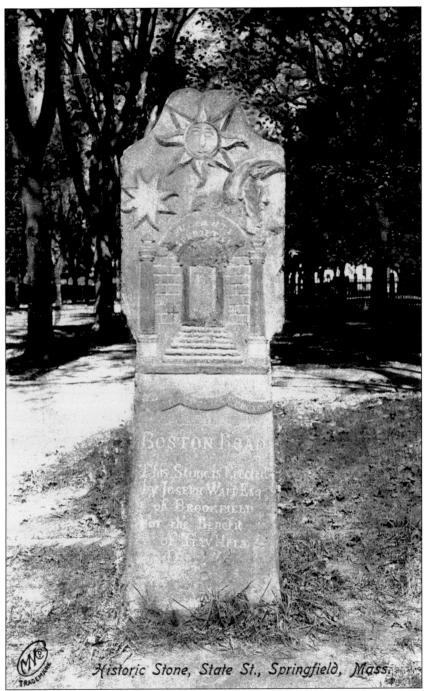

Historic Stone, State St., Springfield, Mass.

In 1763, Brookfield farmer Joseph Wait became lost in a snowstorm, missed the road to Boston, and took the one toward Chicopee. He nearly lost his life. Later that year, he had this marker carved out of stone from the banks of the Connecticut River and installed on what is now State Street near the intersection of Walnut Street. Since that time, it had been moved to the corner of what is now State and Federal Streets. Wait was a Mason, and the stone is decorated with Masonic images. It stood as a guidepost for over 200 years and was removed to preserve it.

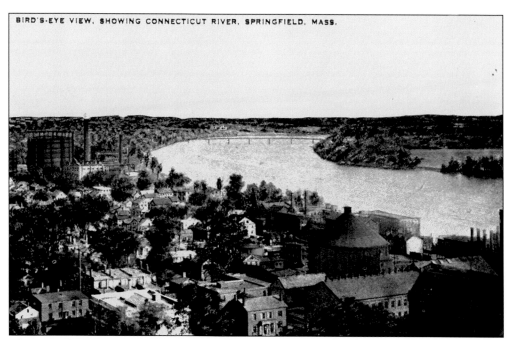

BIRD'S-EYE VIEW, SHOWING CONNECTICUT RIVER, SPRINGFIELD, MASS.

These two bird's-eye views of the city are undated but were published after 1907. The image featuring the bend of the Connecticut River shows the city to the south, while the second view is to the north featuring the railroad bridge in the city's North End.

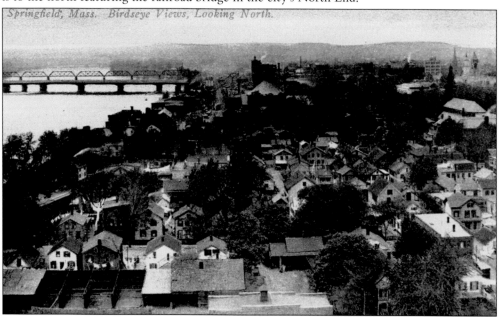

Springfield, Mass. Birdseye Views, Looking North.

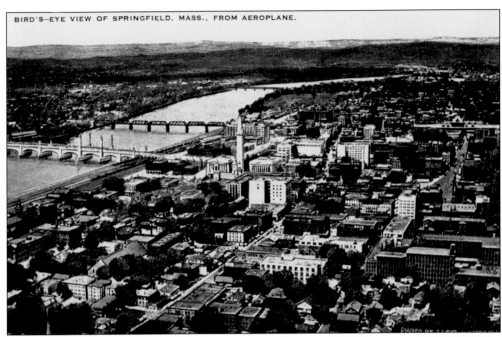

BIRD'S—EYE VIEW OF SPRINGFIELD. MASS.. FROM AEROPLANE.

Photographer Lloyd White Bell took both these aerial views of the downtown. Bell did similar work in 1936 for the city's 300th birthday. Both feature the Municipal Group as the center of the photograph and show what the city looked liked before the construction of Interstate 91 in the late 1950s.

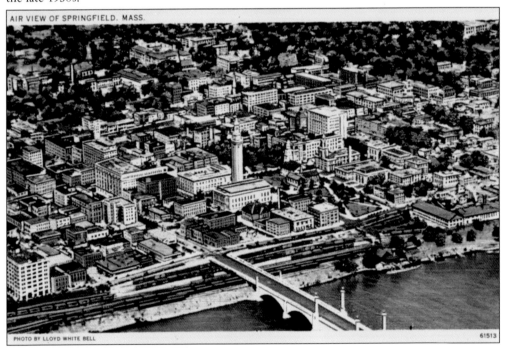

AIR VIEW OF SPRINGFIELD. MASS.

PHOTO BY LLOYD WHITE BELL

61513

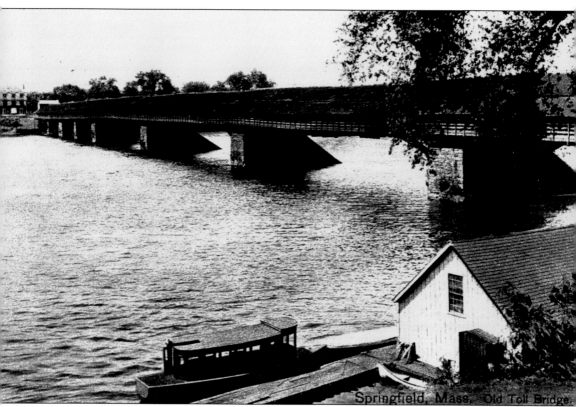

Springfield's first bridge over the Connecticut River was built in 1805. It collapsed in 1814 and was replaced by a covered wooden bridge that was modified in 1818. The Old Toll Bridge, as it was known, remained in service until 1915.

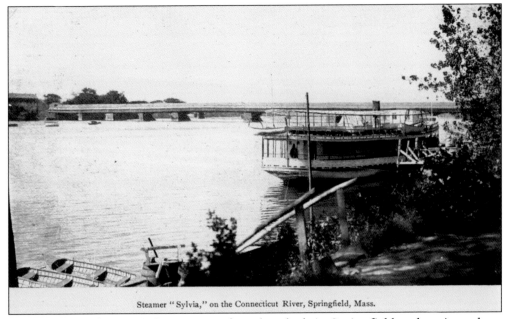

Steamer "Sylvia," on the Connecticut River, Springfield, Mass.

The steamer *Sylvia* carried passengers from her dock in Springfield to locations along the river.

Riverfront, Springfield, Mass.

62828

Here is one pleasure boat steaming past the Old Toll Bridge and in sight of the Municipal Group. Boats took passengers across the river to Agawam's Riverside Park for day excursions.

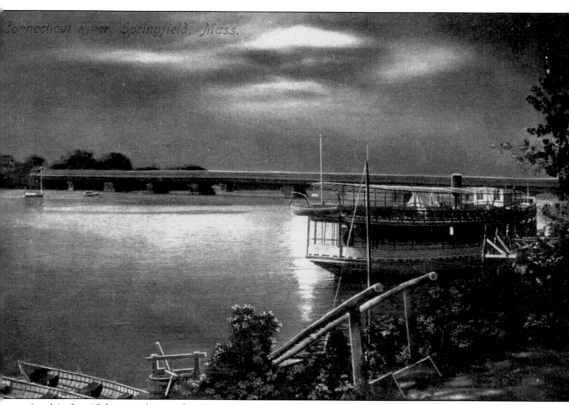

In this fanciful retouching of a daytime photograph, an image of the river under moonlight is created.

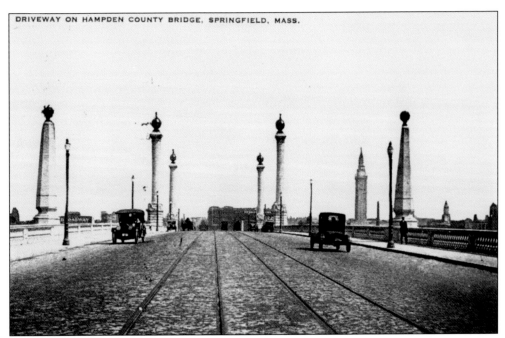

The Memorial Bridge was constructed near the site of the Old Toll Bridge and opened in 1922. In 1996, it underwent a complete renovation that restored such features as its lights. The glass globes had been painted black as preparation for a potential attack during World War II.

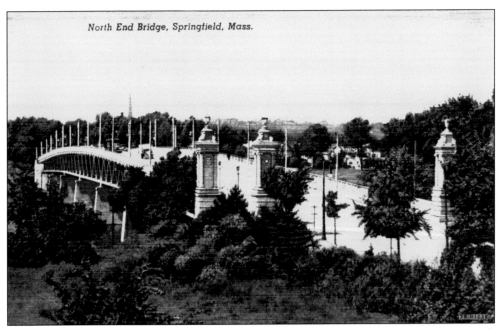

North End Bridge, Springfield, Mass.

The city added two bridges as it grew, the North End Bridge, pictured here, and the South End Bridge.

Two

A THRIVING DOWNTOWN

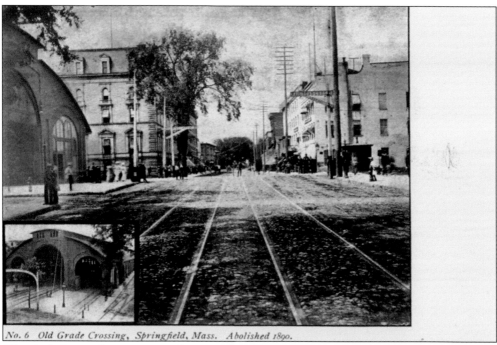

No. 6 Old Grade Crossing, Springfield, Mass. Abolished 1890.

The city's first rail service started in October 1839 when the Western Rail Road Company came to the city. The first station was built just north of Main Street with an Egyptian motif and burned down in 1851. This image shows the city's second station, known as the Old Grade Crossing, which was built in 1851 and used until 1889. It was located on Gridiron Street.

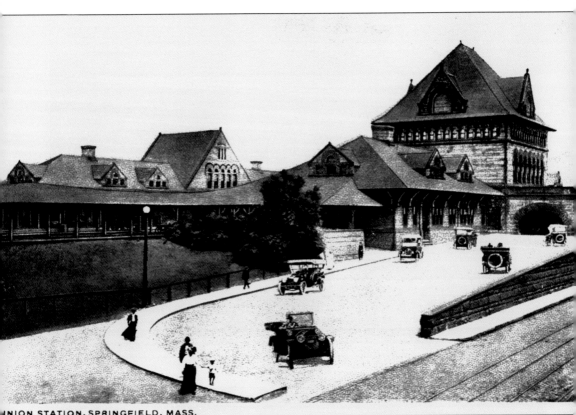

UNION STATION, SPRINGFIELD, MASS.

Construction on Union Station started in 1888 and concluded with its opening on July 7, 1889. It was made of Milford granite and Longmeadow sandstone and was designed by the firm of Shepley, Rutan and Coolidge.

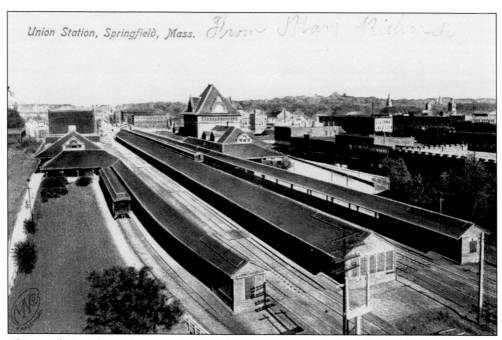

This aerial view shows the covered tracks for passengers constructed for the 1889 station. It was in service until 1925.

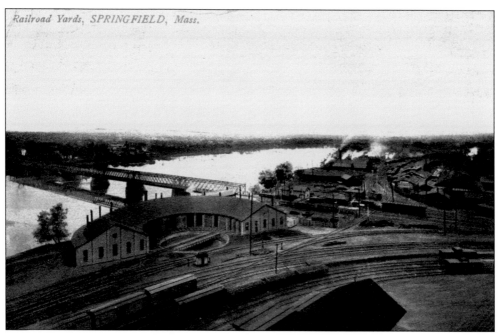

Railroad Yards, SPRINGFIELD, Mass.

The railroad yards were located by the Connecticut River toward the north end of the city. By 1926, there were 97 trains from three rail lines going through Springfield with about 3,000 travelers a day using the station to change trains.

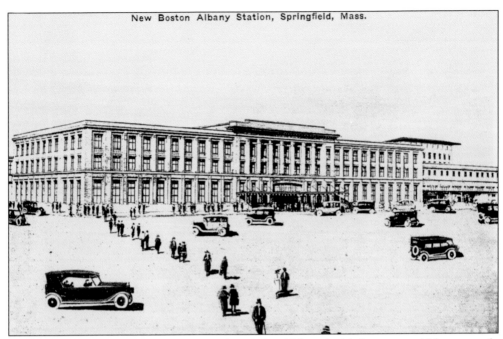

The New Boston Albany Station opened in 1926. Although this image would have people think the station was isolated in some sort of urban plain, it was in the middle of a busy and developed city.

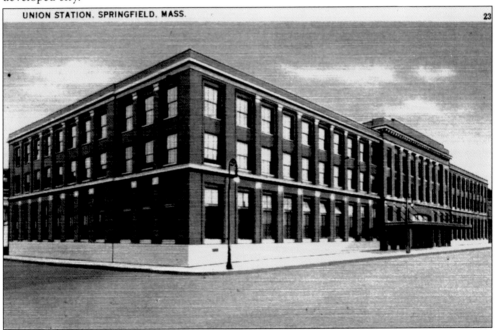

UNION STATION, SPRINGFIELD, MASS. 23

When the station opened, its grand concourse could seat 650 people. The decline of rail travel following World War II had a great impact on the station. By the mid-1950s, the New York Central Railroad was seeking a buyer for the station. The Penn Central eventually found a buyer in 1970. The main part of the station is closed and has been the subject of several failed renovation efforts. Amtrak operates passenger service from a small terminal built next to the tracks.

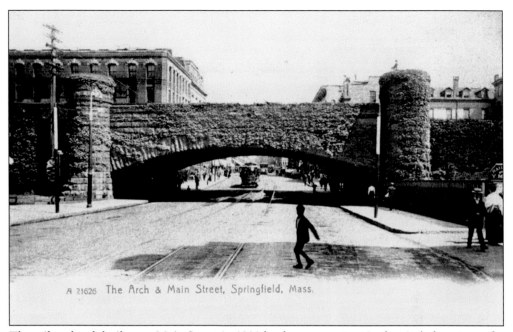

A 21626 The Arch & Main Street, Springfield, Mass.

The railroad arch built over Main Street in 1890 has been a constant in the city's downtown for over a century. These two images show Main Street at a time before automobiles dominated it. Note the two trolley lines that were laid into the center of the street.

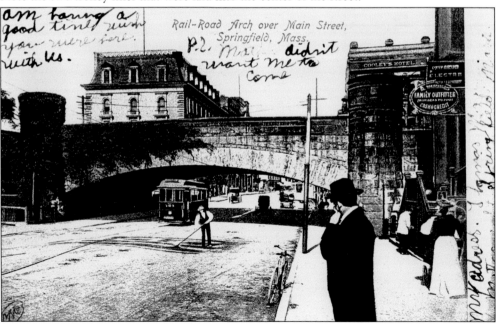

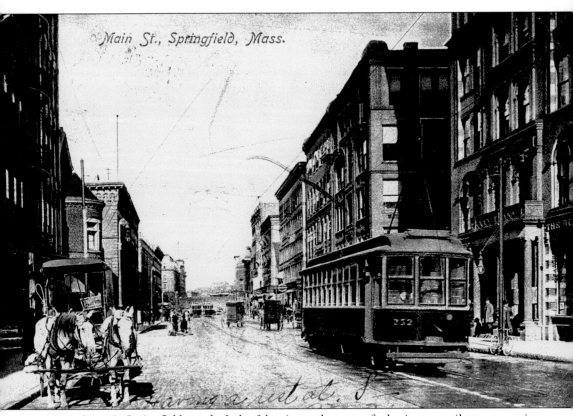

Main Street in Springfield was the hub of the city, as the center for business, retail, transportation, and recreation.

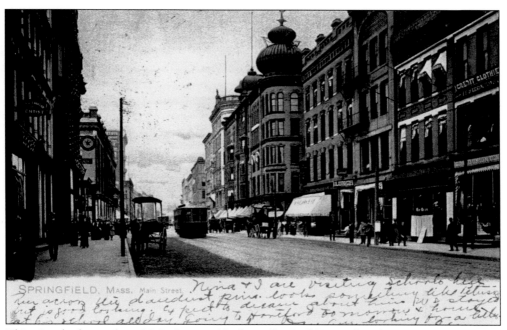

This view looks north on Main Street with the Fuller Building and its distinctive onion roof at the intersection of Main and Bridge Streets.

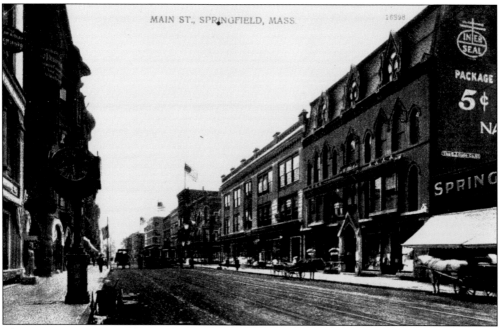

This Main Street image shows the precursor to modern billboards—advertising painted on the side of the building. This sign was for a Nabisco product.

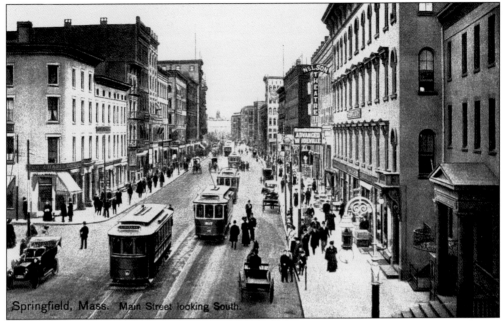

Springfield, Mass. Main Street looking South.

Although different neighborhoods in Springfield had theaters, downtown was the theater district for the city. The Nelson Theatre featuring "advanced vaudeville" can be seen at the right.

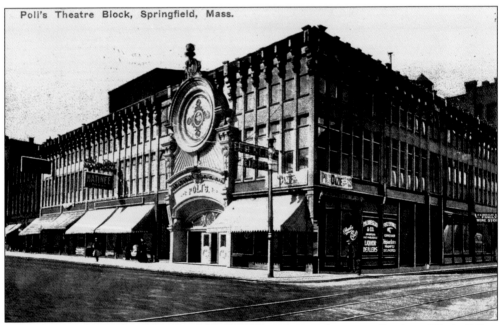

Poli's Theatre Block, Springfield, Mass.

Unlike theaters today, movie and stage houses were just more than an auditorium. The building in which they were located frequently took up an entire block with offices and retail space, such as the Poli.

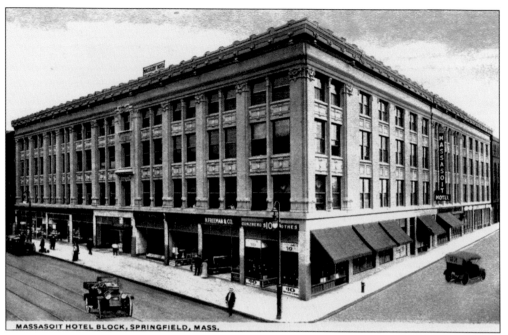

MASSASOIT HOTEL BLOCK, SPRINGFIELD, MASS.

The Massasoit Hotel block was located on the corner of Main and Gridiron Streets. It would become the home of the Paramount Theater, built in 1929 and the only downtown theater to survive to this writing. Contemporary residents know the theater as the Hippodrome. (Courtesy of James Boone.)

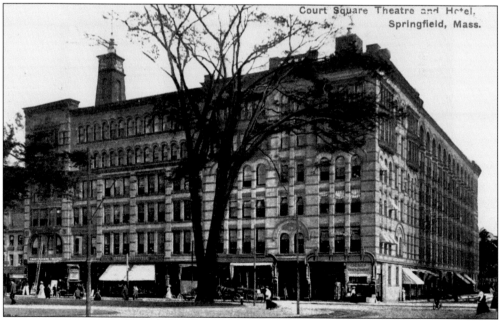

Court Square Theatre and Hotel, Springfield, Mass.

The Court Square Theater and Hotel made up one major part of Court Square and is directly across the square from city hall. The building, complete with its tower, still stands and is planned to undergo a major renovation process. (Courtesy of James Boone.)

49

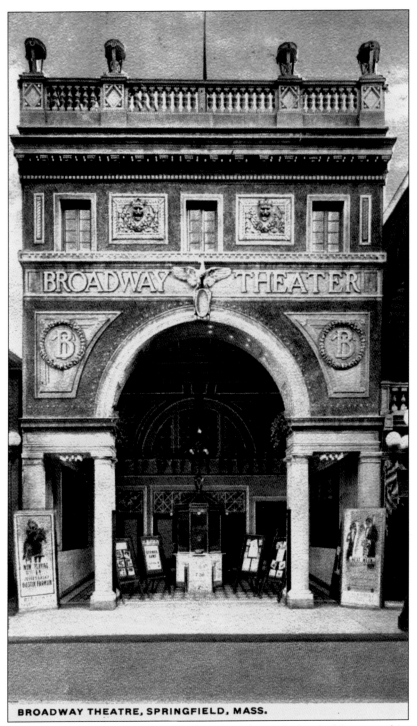

BROADWAY THEATRE, SPRINGFIELD, MASS.

This postcard of the Broadway Theater on Bridge Street shows the level of showmanship common to movie and vaudeville houses. On the sidewalk and near the outdoor ticket stand were placards set up advertising this current program. Unlike today's theaters that hold movies for weeks, theaters then would change bills as often as two times a week. (Courtesy of Robert Walker.)

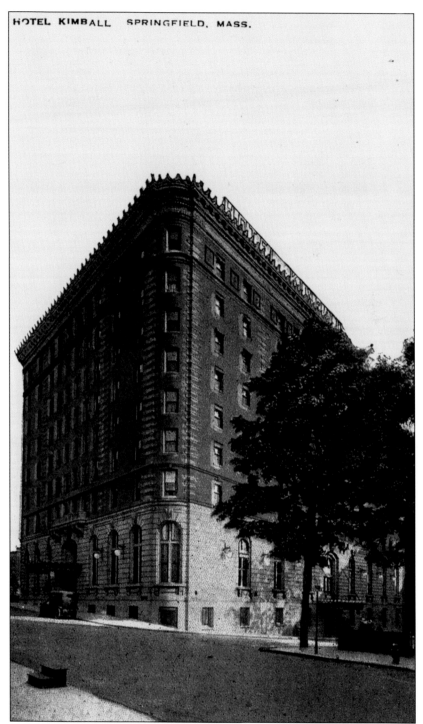

HOTEL KIMBALL SPRINGFIELD, MASS.

As befitting an active rail town, Springfield's downtown boasted a wide variety of hotels. The Hotel Kimball on Chestnut Street was considered to be the city's best hotel. The studio for the nation's first commercial radio station, WBZ (later WBZA), was located at the Hotel Kimball. It has been converted to condominiums.

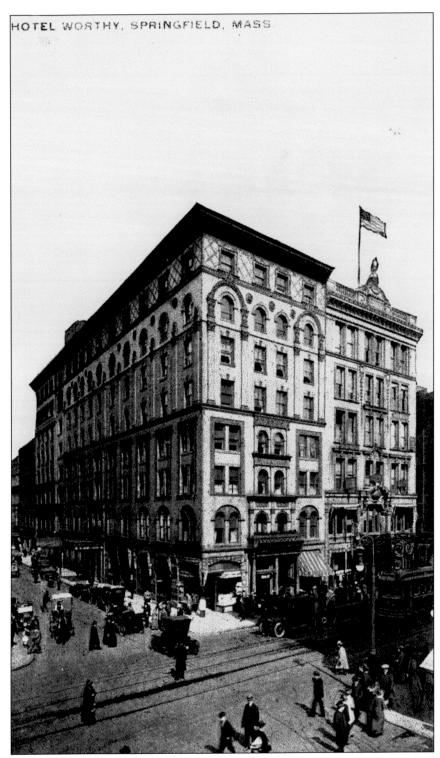

Built in 1905, the Hotel Worthy, on the corner of Main and Worthington Streets, is also still standing and has been converted to apartments.

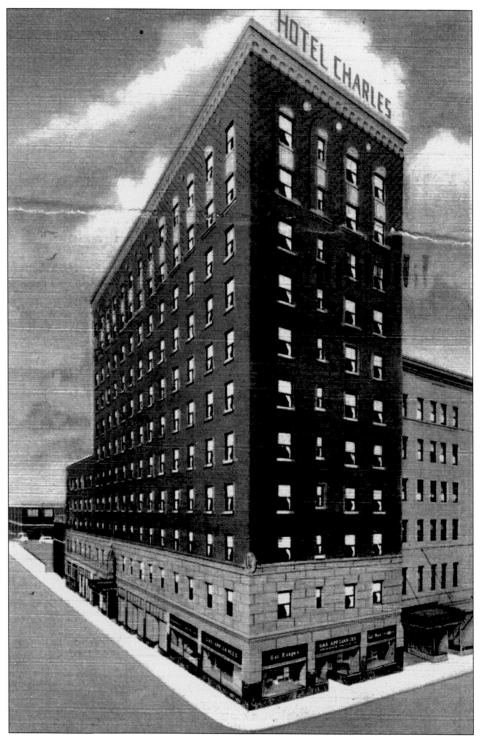

The Hotel Charles was built next to Union Station and was the closest hotel to the station. Falling into disrepair, it was demolished in the 1980s. Ironically, developers since then have cited the location as being perfect for a new hotel. (Courtesy of James Boone.)

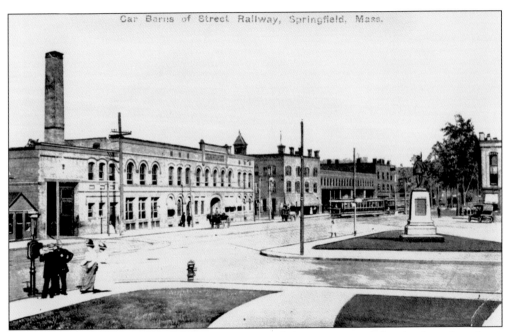

The trolley barns on Main Street that once serviced the streetcars of the city have long been used as service facilities for Peter Pan Buslines. (Courtesy of James Boone.)

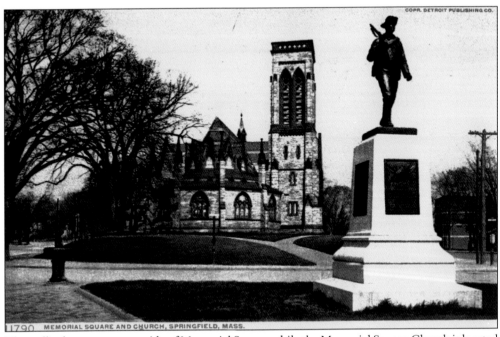

The trolley barns are on one side of Memorial Square while the Memorial Square Church is located on another. Built in 1869, the church grew until the 1930s when changes in the neighborhood saw a decline in the congregation. In 1940, the church was bought by a group of Greek immigrants seeking a permanent location for their church, St. George Orthodox Church.

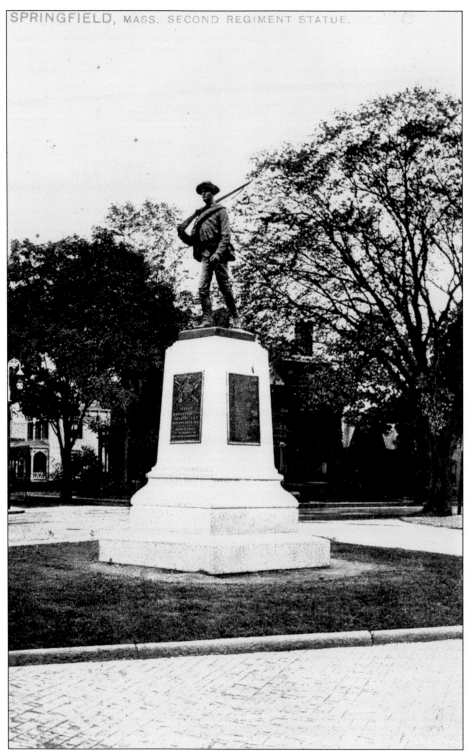

This statue in Memorial Square commemorates the Massachusetts 2nd Regiment, many of them from Springfield, which fought in Cuba in the Spanish-American War.

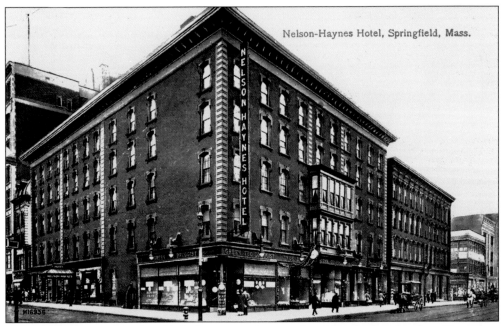

The Nelson-Haynes Hotel on Main Street is no longer a hotel but the location for office space, retails stores, and a series of several popular restaurants and bars. (Courtesy of James Boone.)

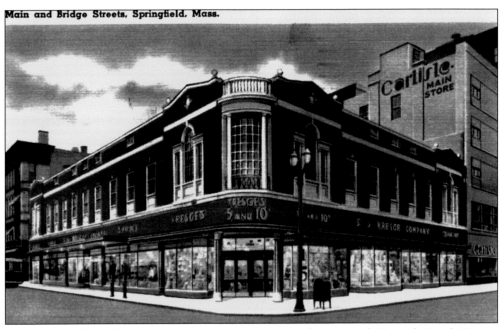

A longtime and popular downtown business is shown in this postcard. Kresge's 5 and 10 store was at the corner of Main and Bridge Streets and was demolished when the federal courthouse and office building was built. (Courtesy of James Boone.)

This postcard from the 1940s shows the other side of Bridge Street. The block seen at the right with the Liggett's Drugstore also contained Steiger's Department Store. That block was demolished after Steiger's Department Store went out of business in 1994 and is currently a park.

G. H. CURTIS.
CLOTHIER,
HATTER AND FURNISHER,
308 MAIN STREET,
SPRINGFIELD, MASS.

Downtown merchants during the 19th century promoted their stores with giveaways, not dissimilar to what some merchants do today. Trade cards such as this one were common items to give customers.

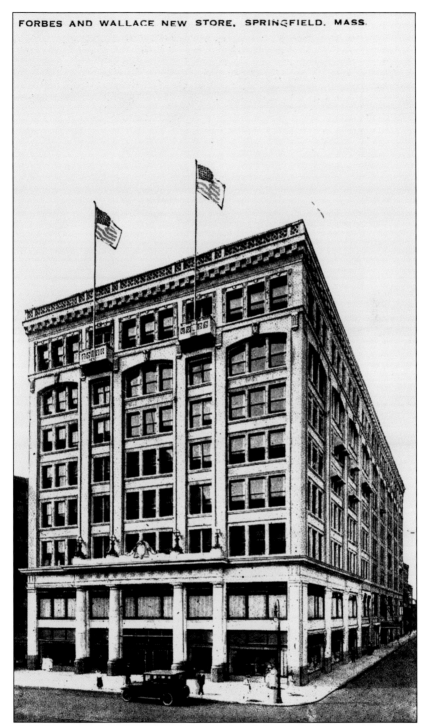

FORBES AND WALLACE NEW STORE, SPRINGFIELD, MASS.

Forbes and Wallace, seen here, was founded in 1874 with its flagship store on the corner of Main and Vernon Streets and was considered by many to be the dominant downtown retailer. Due to the changes in the retail business, it closed in 1976, and the eight-story building was demolished in 1982. Monarch Place, a hotel and office complex, was built on the site in 1987.

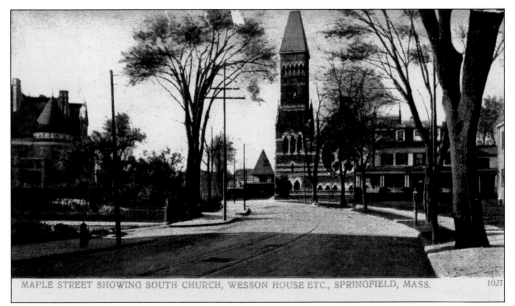

MAPLE STREET SHOWING SOUTH CHURCH, WESSON HOUSE ETC., SPRINGFIELD, MASS. 1027

This view of Maple Street is looking toward the intersection of State Street and shows the South Congregational Church to the right and the home of D. B. Wesson of Smith & Wesson to the left. The church was built in 1875 and designed by William Potter.

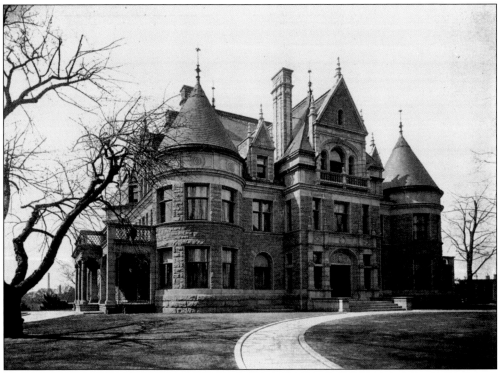

Wesson's mansion, seen in this 1906 photograph, was reported to have cost $1 million. It overlooked the Smith & Wesson factory.

60

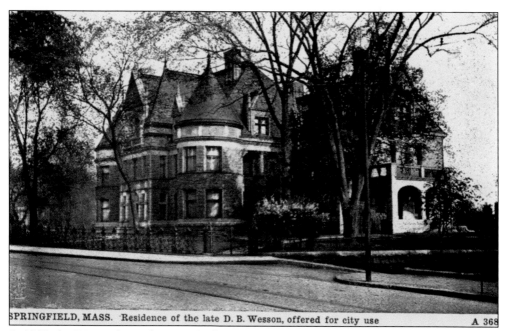

In 1915, the Wesson house became the home of the Colony Club, a private by-invitation-only organization. The club used the mansion until 1966, when it was destroyed in a fire.

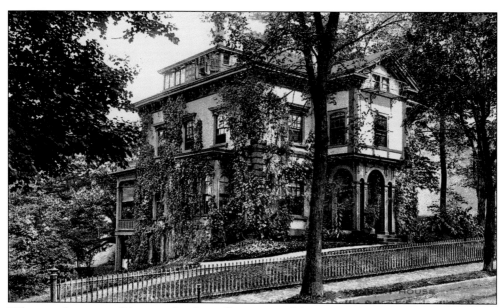

What was known as "the mansion house" was part of the MacDuffie School and located on Central Street not far from the intersection of Maple and Central Streets. The school elected to have the building torn down in the 1980s. (Courtesy of James Boone.)

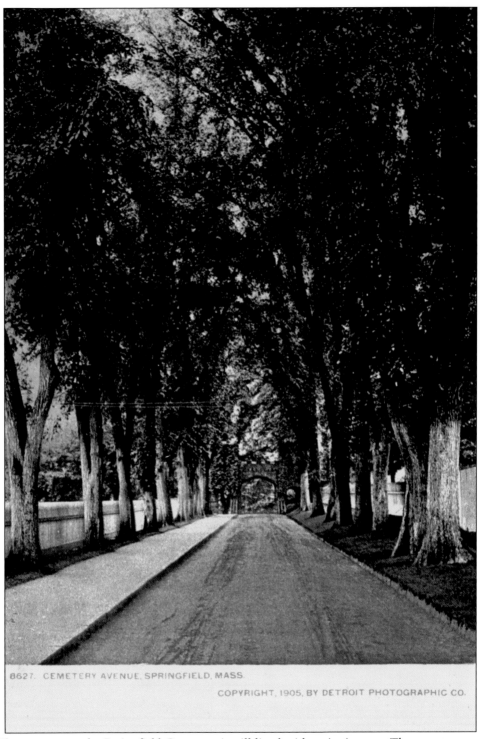

8627. CEMETERY AVENUE, SPRINGFIELD, MASS.

COPYRIGHT, 1905, BY DETROIT PHOTOGRAPHIC CO.

The entrance to the Springfield Cemetery is still lined with majestic trees. The cemetery was dedicated on September 5, 1841, and is the resting place for many prominent citizens. There are graves dating back to 1657 that were moved from the Old First Church burial site.

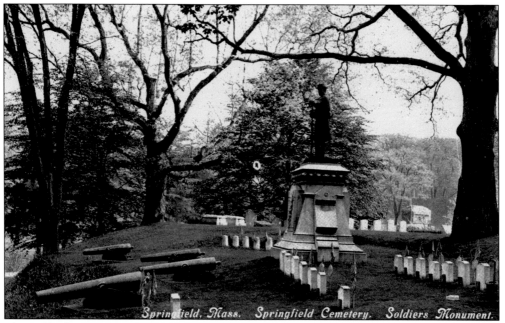

This soldier's monument has been preserved in the Springfield Cemetery with the exception of the cannon. (Courtesy of James Boone.)

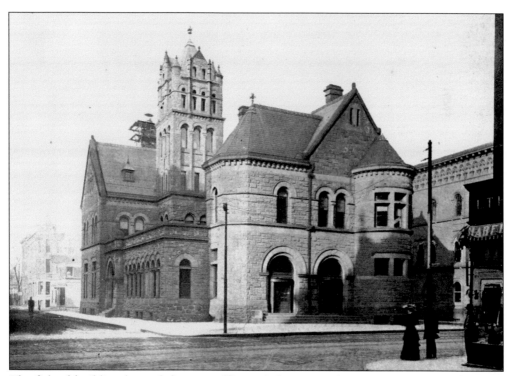

The federal building housed the post office and the custom house on Main Street between Worthington and Fort Streets.

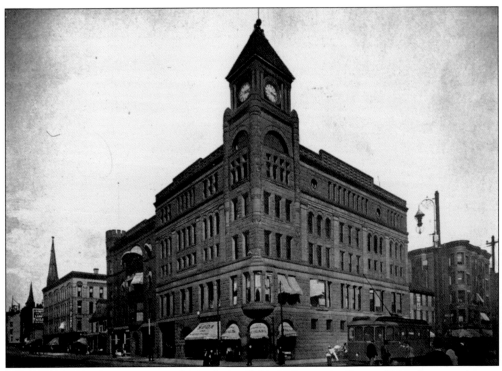

There were several Masonic temples in Springfield. This temple, from a 1906 photograph, was located at the corner of State and Main Streets.

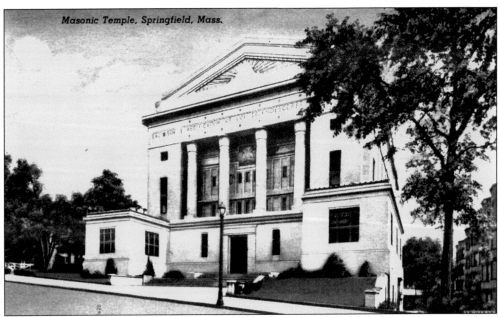

Masonic Temple, Springfield, Mass.

In 1926, the Masonic temple relocated to 339–341 State Street. The building now houses a church.

Another fraternal organization, the Oddfellows had its building, which was built in 1906, on Vernon Street.

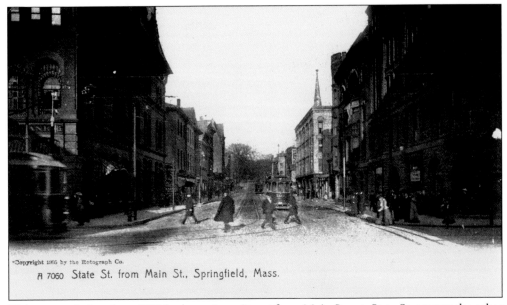

A 7060 State St. from Main St., Springfield, Mass.

This postcard view from 1905 looks up State Street from Main Street. State Street was the other great street in the city. The library, the city's museums, and the Springfield Armory were all off State Street.

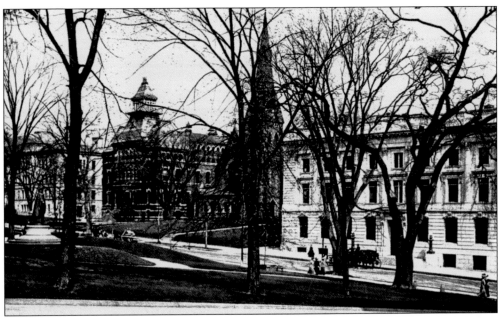

This 1908 postcard shows the Springfield Fire and Marine Insurance Company (the large white stone structure to the right) and the Church of the Unity (center) from the vantage point of Merrick Park.

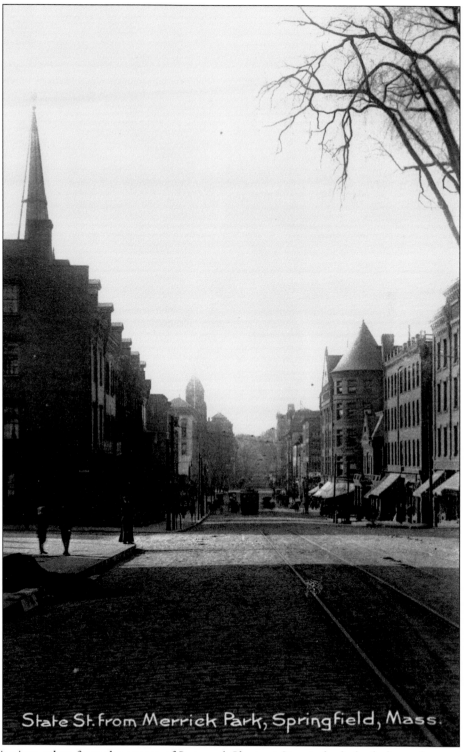

State St. from Merrick Park, Springfield, Mass.

This view, taken from the corner of State and Chestnut Streets, looks back down the street to Main Street. (Courtesy of Robert Walker.)

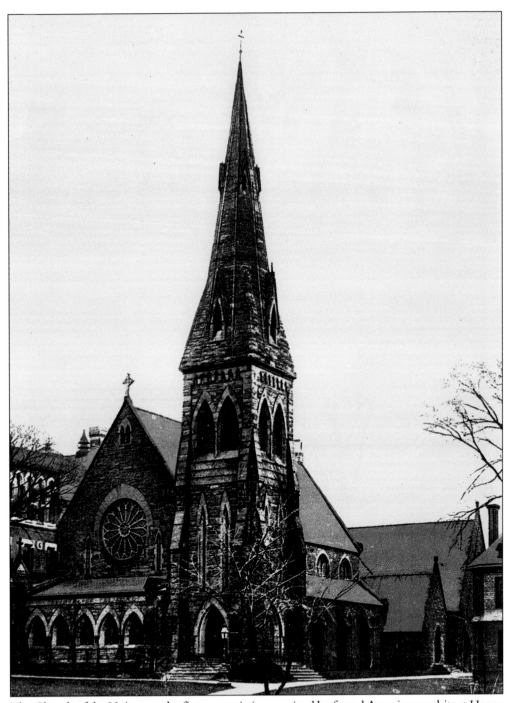

The Church of the Unity was the first commission received by famed American architect Henry Hobson Richardson. The church was under construction from 1866 to 1869. It was demolished in 1962 for a proposed, but never realized, hotel. (Courtesy of James Boone.)

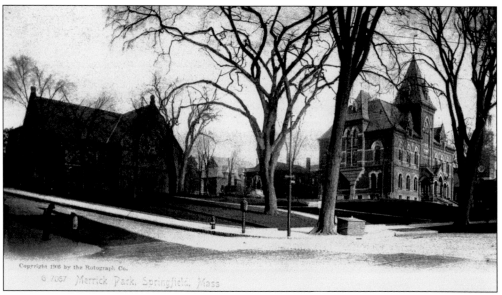

This 1905 view shows Christ Church and the former city library. The statue of Samuel Chapin was moved from Stearns Square in 1899.

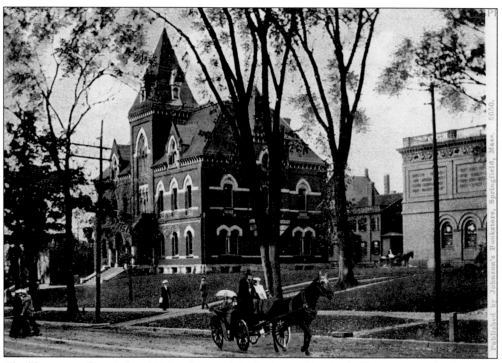

The library was founded in 1857 and was originally located in city hall. It outgrew that location, and funds were raised in 1871 to build a new library near the corner of State and Chestnut Streets. (Courtesy of Robert Walker.)

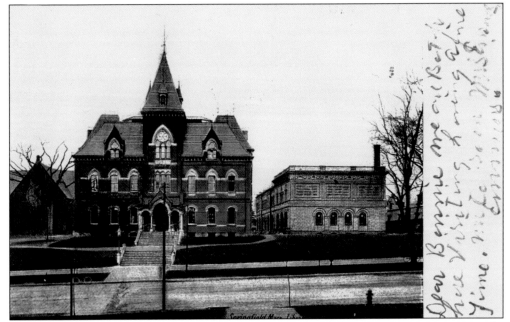

A group of museums were built near the library to form the area known as the Quadrangle. The first museum, the George Walter Vincent Smith Art Museum, was built in 1895 and can be seen above next to the library.

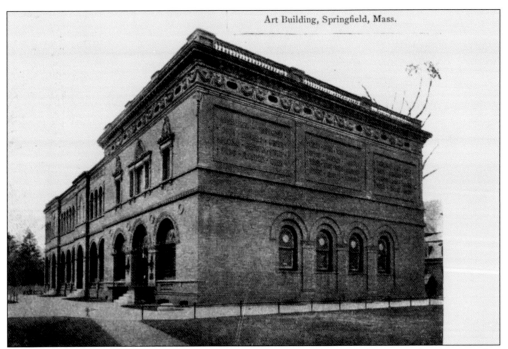

The George Walter Vincent Smith Art Museum housed the diverse collection of George Walter Vincent Smith and his wife, Belle. It included Asian decorative arts, American and Italian paintings, and rugs and textiles.

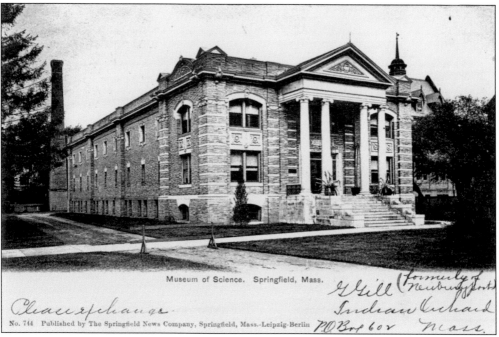

Museum of Science. Springfield, Mass.

No. 744 Published by The Springfield News Company, Springfield, Mass.-Leipzig-Berlin

The Springfield Science Museum was built in 1899 and was greatly expanded in 1934. It is the home of the oldest American-built planetarium, the Seymour Planetarium, opened in 1937.

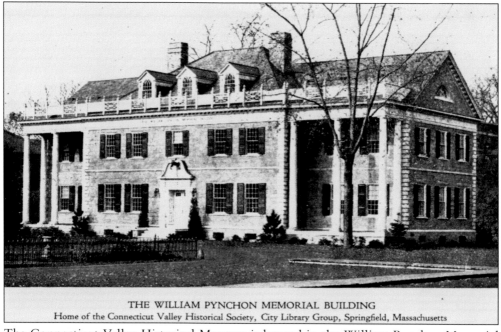

THE WILLIAM PYNCHON MEMORIAL BUILDING
Home of the Connecticut Valley Historical Society, City Library Group, Springfield, Massachusetts

The Connecticut Valley Historical Museum is housed in the William Pynchon Memorial Building, built in 1927.

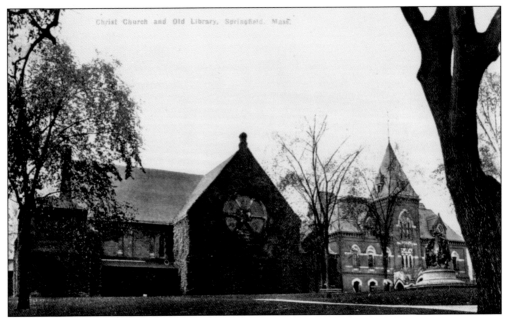

In 1909, the Library Association decided to build a new larger library. Rather than demolishing the older structure and interrupting service, the decision was made to move the library back into the Quadrangle. One can see it here next to Christ Cathedral. According to a 1962 library bulletin recounting the move, patrons were urged to check books out prior to the move to lighten the structure. The move took a little less than three weeks to move the building almost 200 feet. The library was then reopened. (Courtesy of James Boone.)

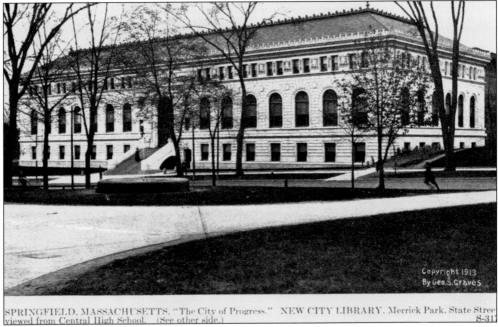

Copyright 1913
By Geo. S. Graves

SPRINGFIELD, MASSACHUSETTS. "The City of Progress." NEW CITY LIBRARY. Merrick Park. State Street, viewed from Central High School. (See other side.) S-31

The present Central Library was opened in 1912 and was funded by a $200,000 gift by philanthropist Andrew Carnegie. The old library was demolished once the new one was in service. In 1998, the library underwent renovations to restore the interior to its original appearance.

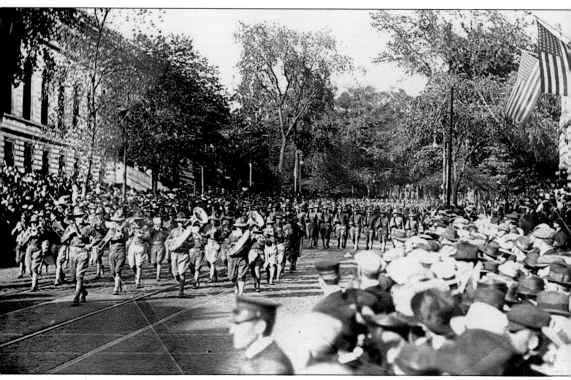

On September 13, 1917, the Massachusetts 104th Regiment marched down State Street as part of a farewell parade before shipping out to duty for World War I. (Courtesy of Robert Walker.)

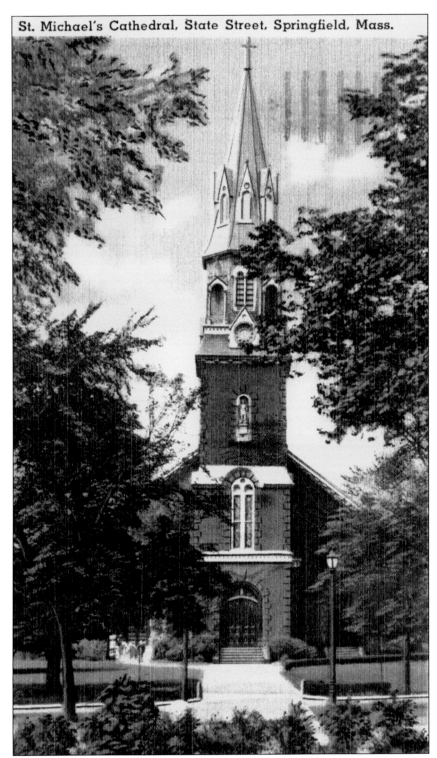

St. Michael's Cathedral, State Street, Springfield, Mass.

With the growing immigrant population, many of them Catholics, St. Michael's Cathedral was built in 1866 on State Street, prior to the organization of the Diocese of Springfield in 1870.

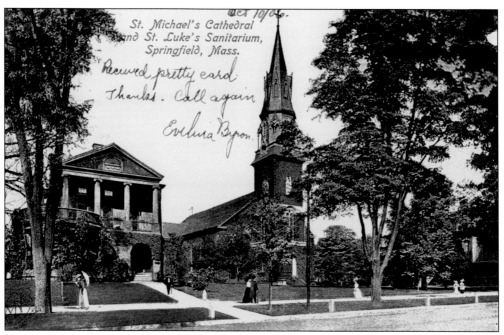

Originally there was St. Luke's Sanitarium built next to the cathedral. (Courtesy of Robert Walker.)

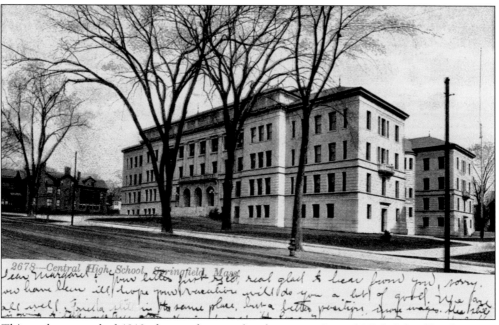

This card, postmarked 1913, shows what was then known as Central High School but later was renamed Classical High School. The school was built in 1898 and closed in 1986. The building was renovated into a successful condominium project.

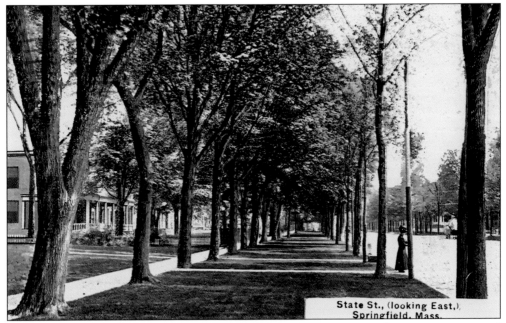

State St., (looking East,), Springfield, Mass.

This postcard shows the tree-lined residential nature of State Street as the street went toward Winchester, now Mason, Square. (Courtesy of Robert Walker.)

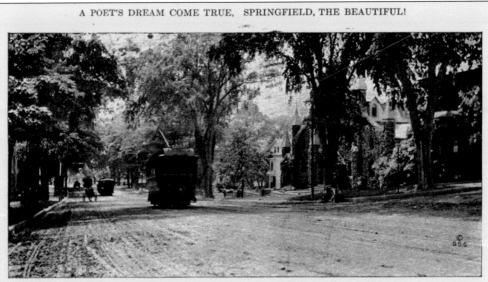

A POET'S DREAM COME TRUE, SPRINGFIELD, THE BEAUTIFUL!

VIEW DOWN STATE STREET, FROM CORNER OF BYERS STREET

State Street is the finest example of a picturesque thoroughfare to be seen in Springfield. From the banks of the Connecticut River it extends the length of the city. In Colonial days it was the "Old Bay Path" and stage road to Boston. Beautiful Elms and Maples line its borders for miles. (See other side.) A 576

This view of State Street from Byers Street is near the entrance of the Springfield Armory compound. (Courtesy of Robert Walker.)

Three

AROUND THE TOWN

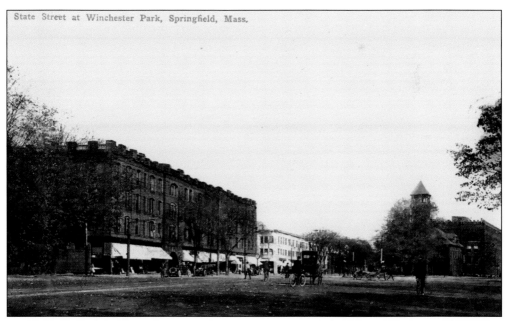

State Street at Winchester Park, Springfield, Mass.

Winchester Square is now known as Mason Square, named for Primus Mason, the benefactor who sold the city the land for just $65 under the condition that it be used for public purposes. Mason, who lived from 1817 to 1892, was a successful African American farmer and real estate investor. (Courtesy of Robert Walker.)

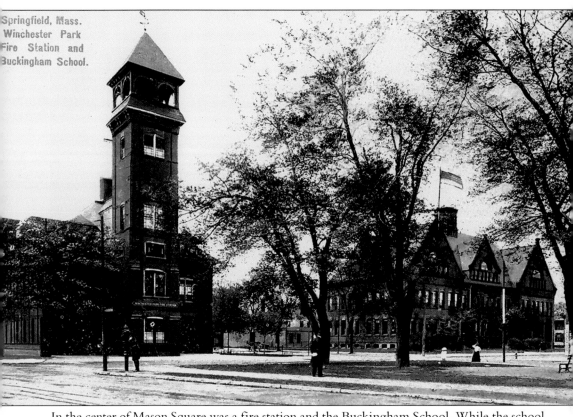

In the center of Mason Square was a fire station and the Buckingham School. While the school has long been demolished, the fire station is still standing and is awaiting a new use. (Courtesy of Robert Walker.)

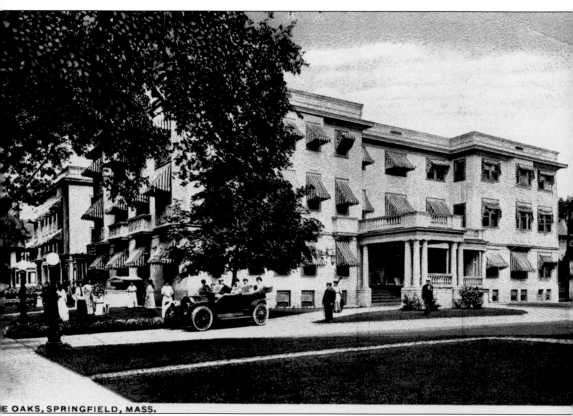

E OAKS, SPRINGFIELD, MASS.

The Oaks, at the corner of State Street and Thompson Street, was a longtime Springfield landmark for gracious dining. (Courtesy of James Boone.)

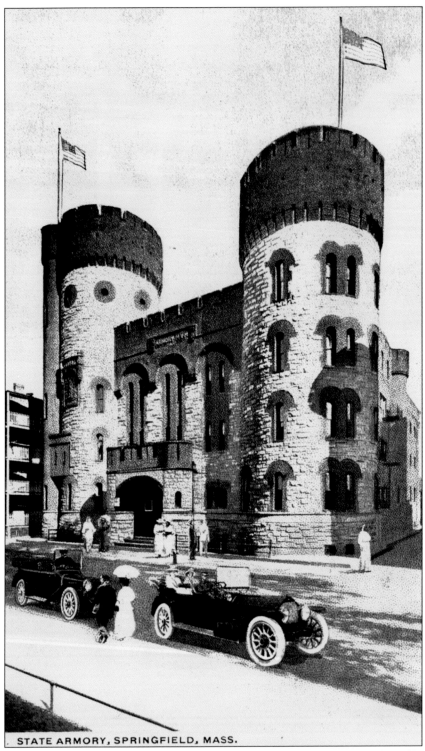

STATE ARMORY, SPRINGFIELD, MASS.

In 1915, the state built an armory building on Howard Street in the city's South End neighborhood. The building is now used as the South End Community Center.

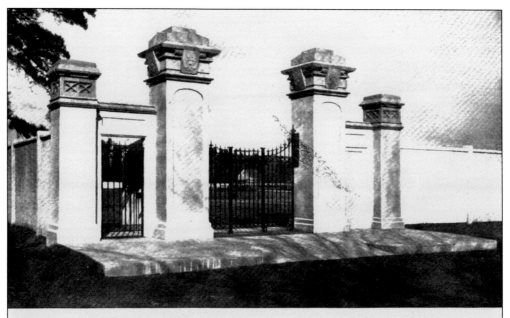

SPRINGFIELD, MASS. ORNATE ENTRANCE TO PRATT FIELD of International Y. M. C. A. Training

The International YMCA Training School was founded in 1885 to train professionals to staff YMCA facilities around the world. It was later renamed Springfield College. These gates led to the college's Pratt Field. (Courtesy of James Boone.)

The campus of the International YMCA Training School was built along the banks of Lake Massasoit.

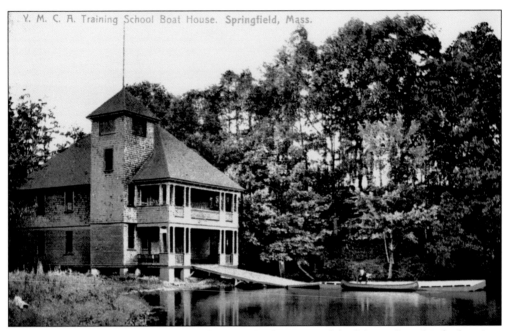

The International YMCA Training School took advantage of the lake and used it for boating. (Courtesy of James Boone.)

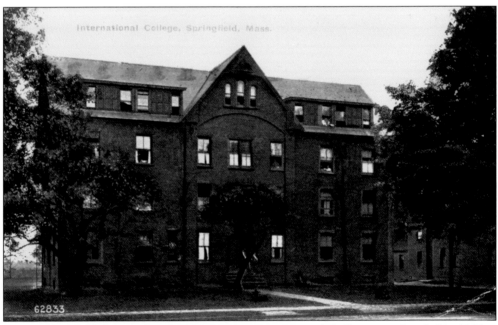

International College, now known as American International College, was founded in 1885 as a college to provide French Canadian youth with access to higher education. This postcard is postmarked 1917. (Courtesy of James Boone.)

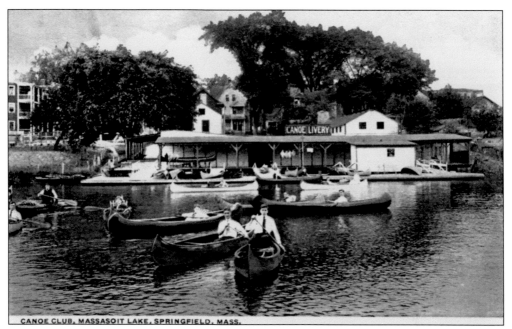

CANOE CLUB, MASSASOIT LAKE, SPRINGFIELD, MASS.

Lake Massasoit is also known as Watershops Pond as it provided the waterpower for part of the Springfield Armory complex. It was also a location for boating and swimming in the city, as seen in this image dated 1917. (Courtesy of James Boone.)

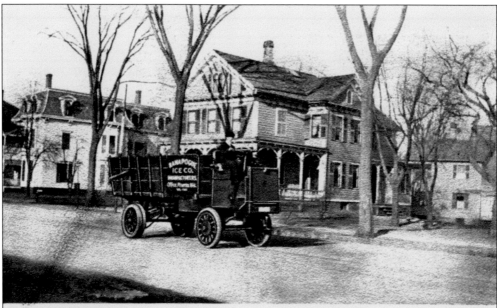

UP-TO-DATE TRUCK OF RAMAPOGUE ICE COMPANY. The *only* manufacturers in Springfield of HYGIENIC ICE. Nothing but PURE SPRING WATER used. QUICK DELIVERIES ON HURRY ORDERS.

The ice truck, seen in this postcard dated 1911, was a familiar sight in the city. (Courtesy of Robert Walker.)

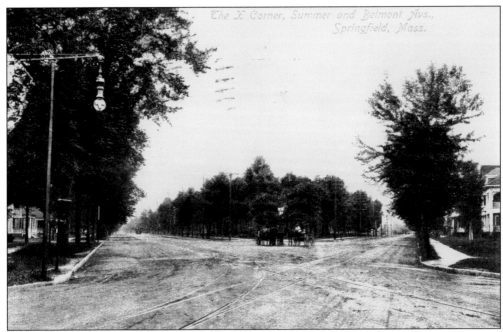

The Forest Park neighborhood also became well known for its wide streets and homes built during the late 19th century. The intersection of Sumner and Belmont Avenues was known as the "X" even in 1909, when this card was postmarked, although today one could not stop and talk as the drivers of these two carriages did. The other image of Sumner and Forest Park Avenues, postmarked 1911, shows the ornate streetlight.

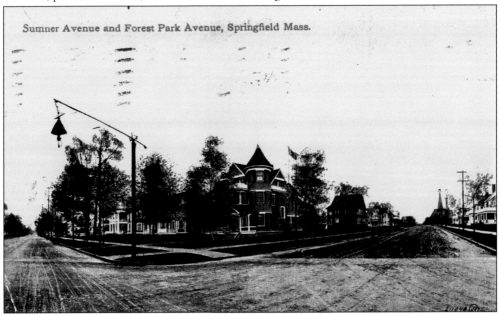

Sumner Avenue and Forest Park Avenue, Springfield Mass.

84

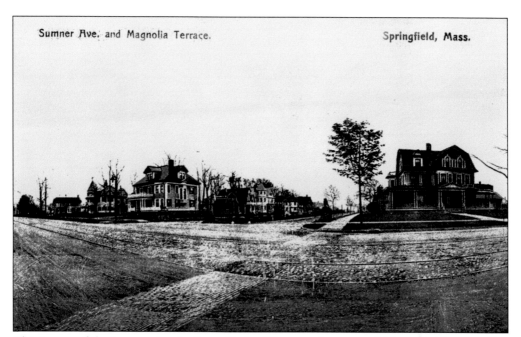

Sumner Ave. and Magnolia Terrace. Springfield, Mass.

This image of the intersection in Forest Park of Sumner Avenue and Magnolia Terrace offers another view of this new neighborhood. (Courtesy of James Boone.)

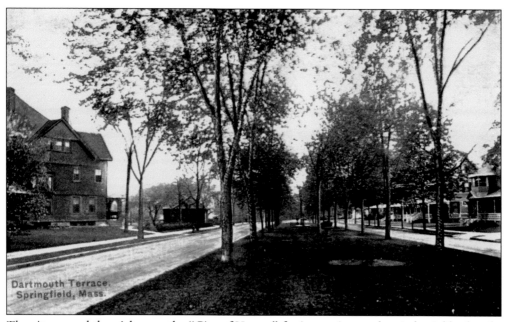

Dartmouth Terrace.
Springfield, Mass.

The city earned the nickname the "City of Homes" for its gracious and varied neighborhoods. Dartmouth Terrace, as seen in this postcard, was part of the Hill-McKnight neighborhood built in the late 19th century. (Courtesy of James Boone.)

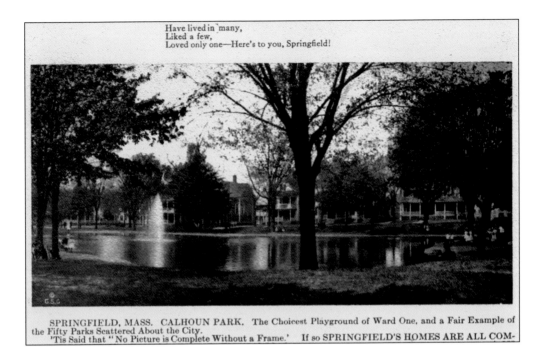

Have lived in many,
Liked a few,
Loved only one—Here's to you, Springfield!

SPRINGFIELD, MASS. CALHOUN PARK. The Choicest Playground of Ward One, and a Fair Example of the Fifty Parks Scattered About the City.
'Tis Said that "No Picture is Complete Without a Frame.' If so SPRINGFIELD'S HOMES ARE ALL COM-

There were numerous parks built throughout the city, and Calhoun Park is seen in these two postcard views. (Courtesy of Robert Walker.)

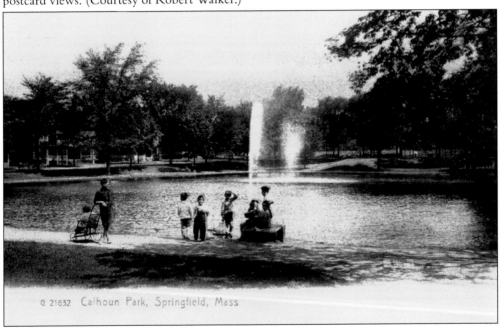

G 21632 Calhoun Park, Springfield, Mass

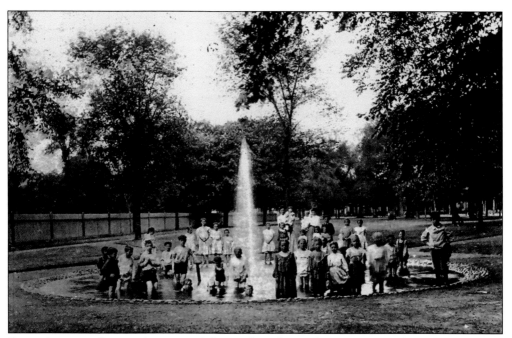

Fountains were fixtures in many of the city's parks, such as Benton Park, and used by the neighborhood children. (Courtesy of Robert Walker.)

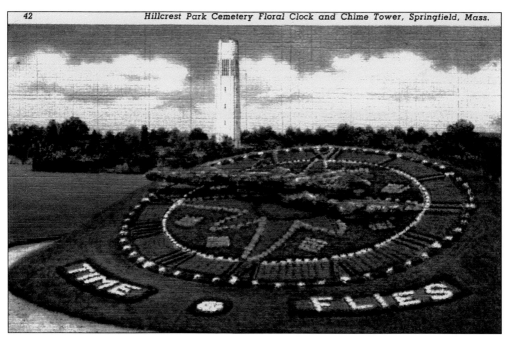

A park of a different kind could be found in the Hillcrest Park Cemetery that featured a floral clock with the inscription "Time flies."

North Chestnut Street School served as middle school for many years and is now being considered for a renovation project to turn it into housing.

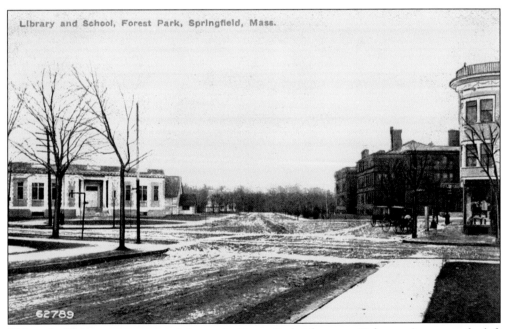

Library and School, Forest Park, Springfield, Mass.

62789

This early-20th-century postcard shows the Forest Park Library on Belmont Avenue at the left and the Forest Park Middle School in the right background. The neighborhood was still being developed. (Courtesy of Robert Walker.)

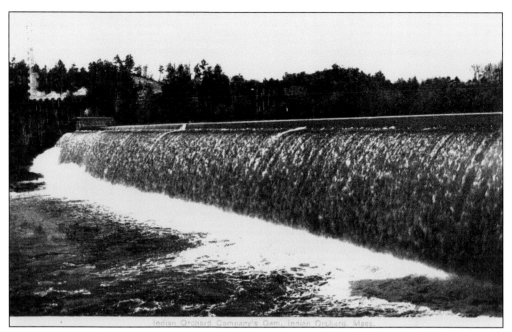

Although the Connecticut River attracted settlers to Springfield, it was the falls of the Chicopee River that brought people to the town of Indian Orchard. Manufacturers built a dam in 1846 to control the waterpower. Once a separate community, it was incorporated into the City of Springfield. The falls that provided waterpower for mills are still generating electricity today.

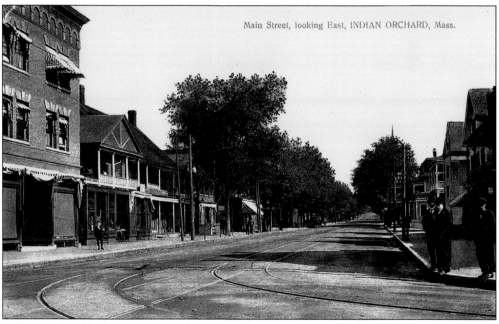

Indian Orchard had its own Main Street, confusing people to this day about how a city could have two Main Streets. (Courtesy of Robert Walker.)

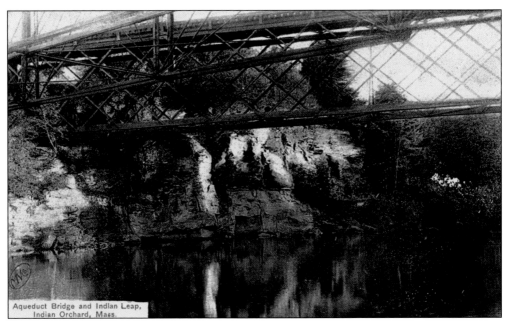

Aqueduct Bridge and Indian Leap,
Indian Orchard, Mass.

There are two legends concerning the area along the Chicopee River known as Indian Leap. One tells of a group of Native Americans who chose suicide rather than being captured by settlers following the burning of Springfield in 1675. Another explanation is that settlers named the area after seeing Native Americans diving and swimming there. (Courtesy of Robert Walker.)

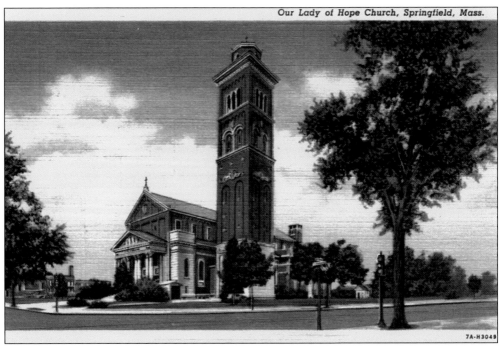

Our Lady of Hope Church, Springfield, Mass.

7A-H3049

Our Lady of Hope Church, located in the Hungry Hill neighborhood, features a 150-foot bell tower. Construction started on the church in 1925 but was not completed until 1938.

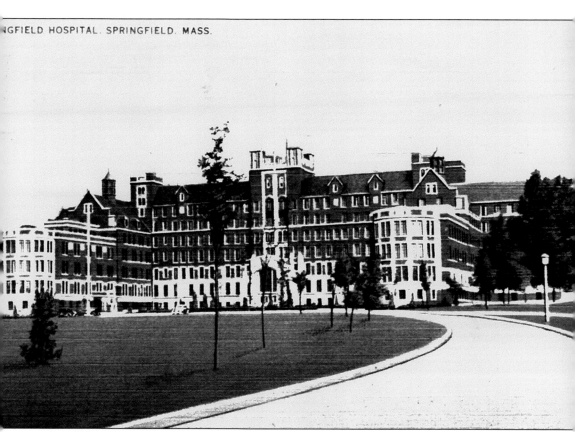

Springfield Hospital, now known as Baystate Medical Center, was founded when a bequest from Dorcas Chapin left $25,000 to be used to purchase the Fuller farm on North Chestnut Street in 1886. The hospital's first incarnation opened in 1889. This view is from the 1940s.

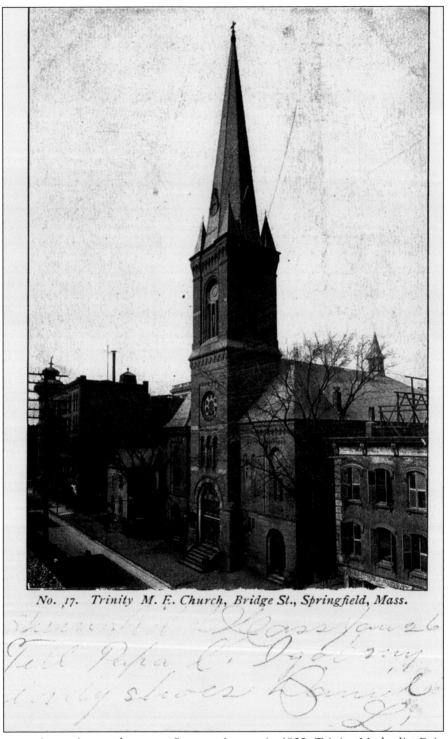

No. 17. Trinity M. E. Church, Bridge St., Springfield, Mass.

Before moving to its new home on Sumner Avenue in 1925, Trinity Methodist Episcopal Church was located on Bridge Street. In the 1920s, a number of Springfield city businesses and institutions moved to new locations due to growth.

Four

CITY AT WORK

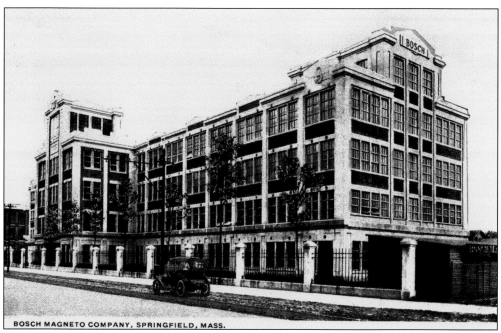

BOSCH MAGNETO COMPANY, SPRINGFIELD, MASS.

The Bosch Magneto Plant became known to generations of Springfield residents as American Bosch. The plant was founded in 1910 and operated until 1986, when its owner United Technologies moved the operation to other facilities. The building sat largely vacant and was destroyed by fire in 2004. The site, which sits on the border between Springfield and Chicopee, is now considered a prime area for development. (Courtesy of Robert Walker.)

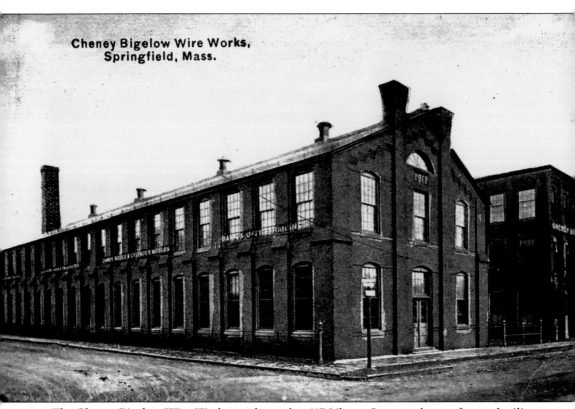

Cheney Bigelow Wire Works,
Springfield, Mass.

The Cheney Bigelow Wire Works was located at 417 Liberty Street and manufactured railings, elevator cabs and enclosures, window guards, and brass, copper, and iron wire cloth. (Courtesy of Robert Walker.)

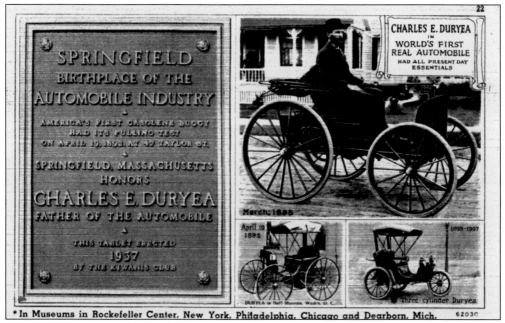

This is a commemorative postcard noting the first successful American-made, gasoline-powered car developed by Charles and Frank Duryea in Springfield in 1893. In 1896, the brothers offered the first commercially produced automobile for sale. (Courtesy of Robert Walker.)

This 1906 Stevens-Duryea car was a product of the factory formed by J. Stevens Arms and Tool Company of Chicopee with Frank Duryea in 1904. Stevens-Duryea produced about 14,000 cars before it closed in 1915. It reopened without Duryea involved in 1919 and closed again in 1925.

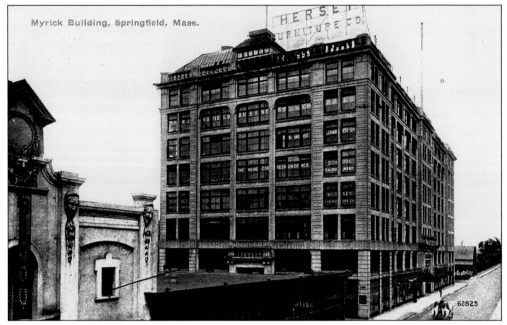

The Myrick Building was the home of several Springfield concerns, as can be seen in its windows. Note to the left the facade of the Bijou Theater. (Courtesy of Robert Walker.)

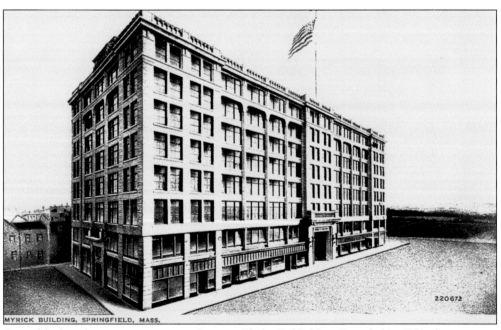

One of the best-known tenants at one time was Phelps Publishing. Founded in 1880, the company published a variety of magazines, with its best-known being *Good Housekeeping* magazine.

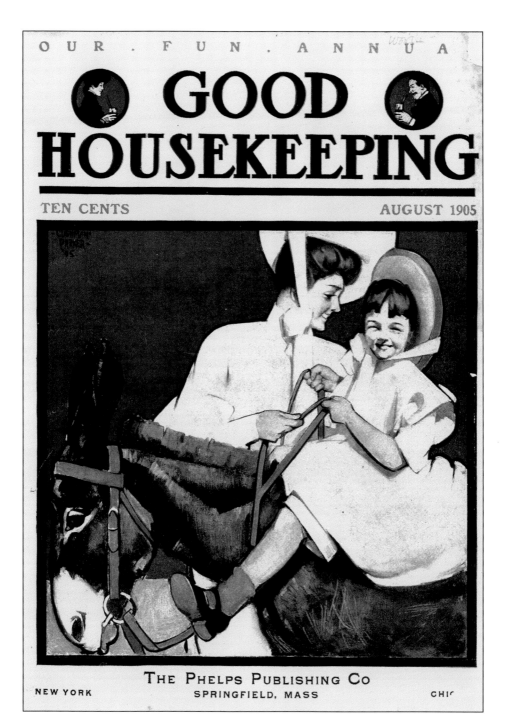

Good Housekeeping revolutionized the magazine industry by extending a guarantee to its readers: "We guarantee the reliability of every advertisement inserted in Good Housekeeping. We mean that you shall deal with our advertisers in the confidence that you will be fairly and squarely treated. If, in spite of all our care, some advertisement should be admitted through which any subscriber is imposed upon or dishonestly dealt with, we will make good to such subscriber the full amount of this loss."

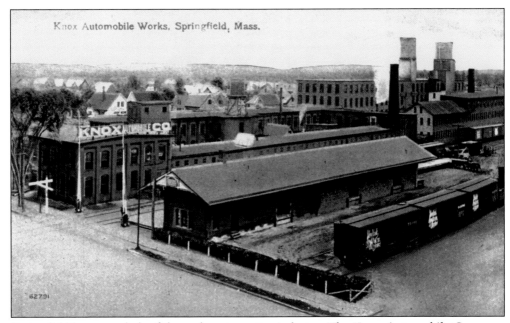

Springfield became a hub of the early automotive industry. The Knox Automobile Company not only made cars at its Wilbraham Road plant but also was the first company to manufacture modern fire trucks. (Courtesy of James Boone.)

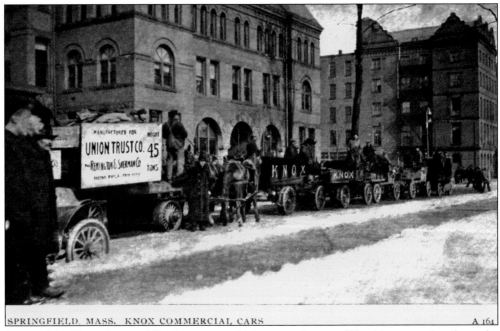

Some of the Knox Automobile Company vehicles were shown off in this promotional parade. (Courtesy of Robert Walker.)

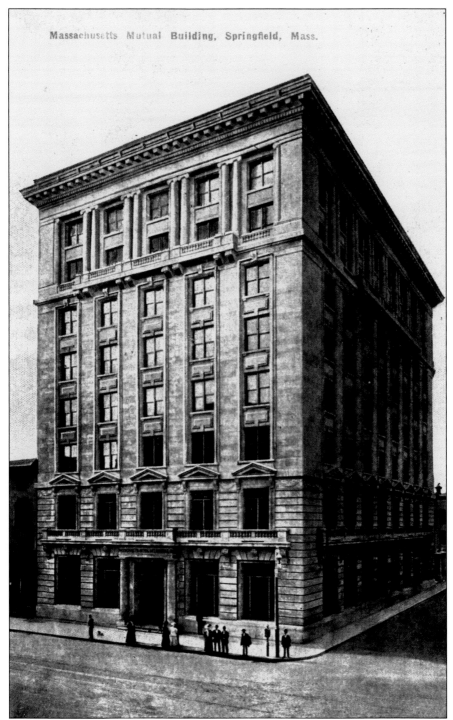

Massachusetts Mutual Building, Springfield, Mass.

The Massachusetts Mutual, now known as Mass Mutual, moved into this building on State and Main Streets in 1908. In 1926, the company had outgrown this location and built its present headquarters on upper State Street in what was described as the "outskirts" of the city. (Courtesy of Robert Walker.)

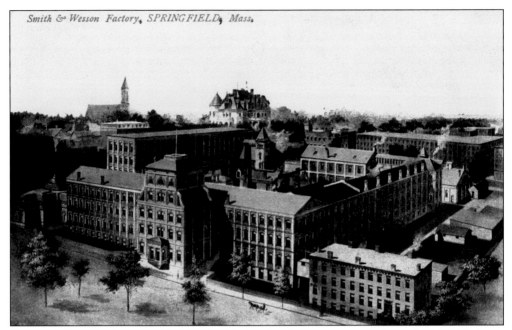

Smith & Wesson Factory, SPRINGFIELD, Mass.

Few manufacturers are more identified with the city than gun manufacturers Smith & Wesson. After a series of technological successes and business failures, Daniel Wesson and Horace Smith came to Springfield to try gun manufacturing again in 1856. Their success compelled them to build a new factory on Stockbridge Street, not far from the Springfield Armory, in 1863. Wesson's mansion on Maple Street can be seen in the background.

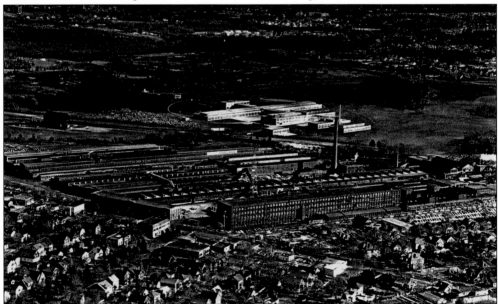

Smith & Wesson opened its new plant in 1949 after two years of construction. It is the complex of white buildings in the center of the image. The other factory complex is the home of Westinghouse and where the Stevens-Duryea plant was. The two radio towers were for WBZ (later WBZA), the first commercial radio station in the United States. The first broadcast was made on September 19, 1921.

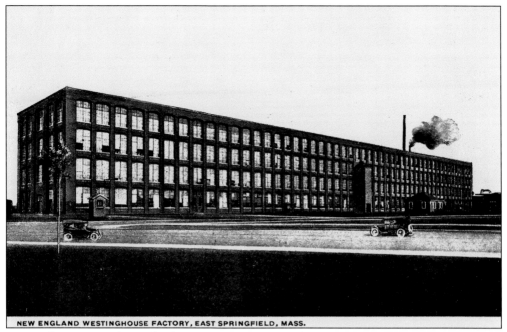

NEW ENGLAND WESTINGHOUSE FACTORY, EAST SPRINGFIELD, MASS.

Westinghouse moved into the former Stevens-Duryea facility in 1915 and eventually became the city's largest employer with 5,000 workers. The plant made a variety of items and was closed in 1970 after a 12-year phaseout. (Courtesy of Robert Walker.)

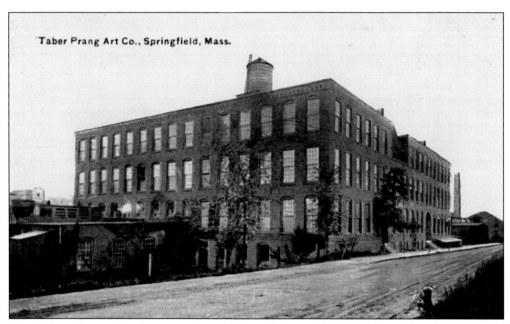

Taber Prang Art Co., Springfield, Mass.

The Tabor Prang Art Company manufactured postcards and lithographs. (Courtesy of James Boone.)

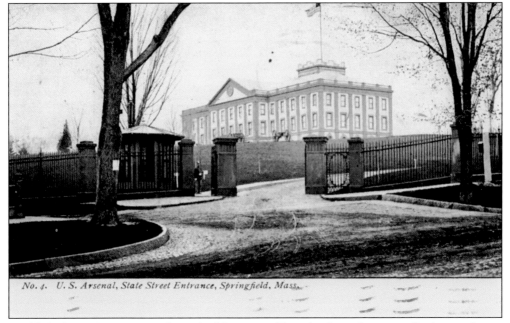

No. 4. *U. S. Arsenal, State Street Entrance, Springfield, Mass.*

Established in 1794, to ensure the United States would not be dependent upon foreign producers of arms for the American military, the Springfield Armory was, in many ways, responsible for the manufacturing success of the city. It drew skilled workers who created the necessary labor pool.

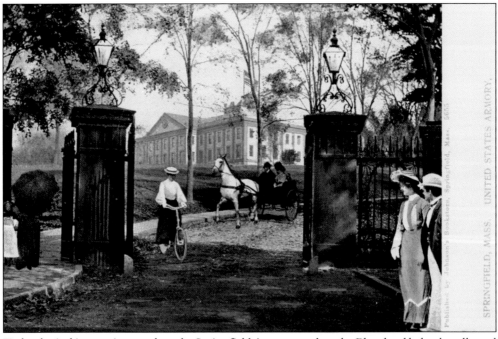

Technological innovations made at the Springfield Armory, such as the Blanchard lathe that allowed for the mechanized production of irregular wooden shapes, were applied to other industries.

Although presented like a park in many images, the Springfield Armory has the serious business of developing and manufacturing many of the weapons used by the American military. Perhaps its most famous weapon was the M1 rifle adopted by the U.S. Army in 1936 and used as the standard infantry weapon until it was phased out in 1957.

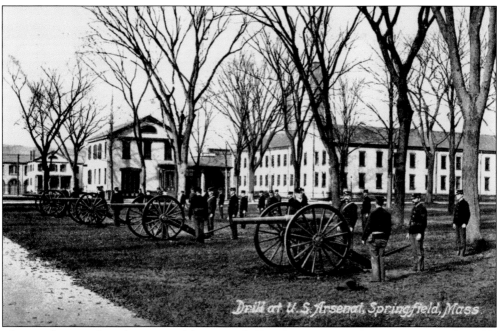

The parade grounds in the center of the Springfield Armory compound were used to drill troops. (Courtesy of James Boone.)

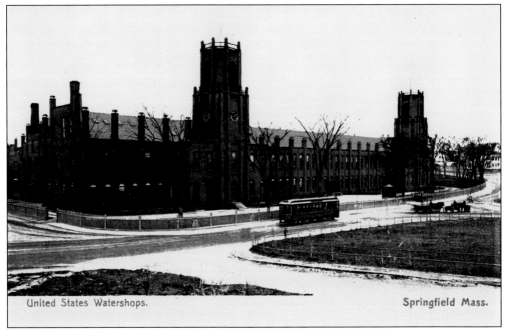

United States Watershops. Springfield Mass.

The Springfield Armory's facilities were located in two locations in the city: on State Street and at the Watershops on Lake Massasoit. The Watershops complex is not part of the Springfield Armory Museum operated by the National Park Service and is privately owned. A number of small businesses use the facility.

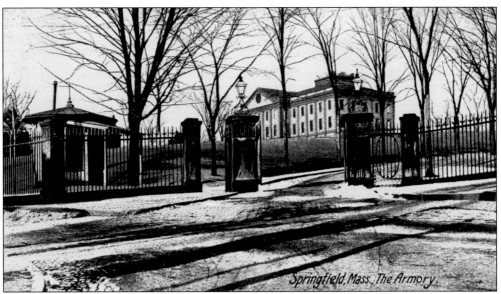

Springfield Mass., The Armory.

City and state officials were unsuccessful in fighting the Department of Defense decision to close the Springfield Armory in 1968. The Springfield Armory grounds became home to Springfield Technical Community College and to a technology park hosting a number of businesses.

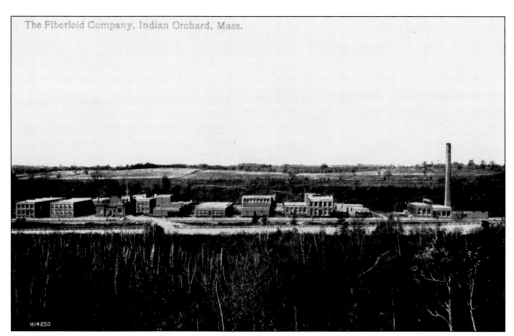

The Fiberloid Company in Indian Orchard has been in the city since 1904, initially producing celluloid and plastics. Known for many years as Monsanto, the company is still in business under the name Solutia. (Courtesy of James Boone.)

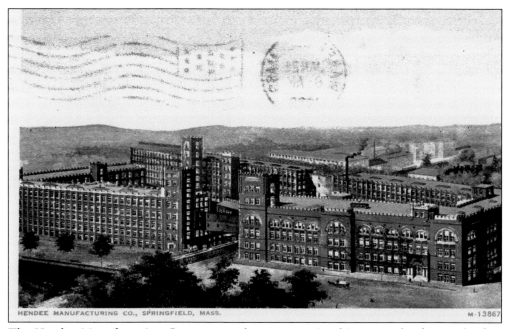

The Hendee Manufacturing Company made transportation history in developing the first American motorcycle. This was the company's second factory, shaped like an arrowhead at Mason Square. (Courtesy of Robert Walker.)

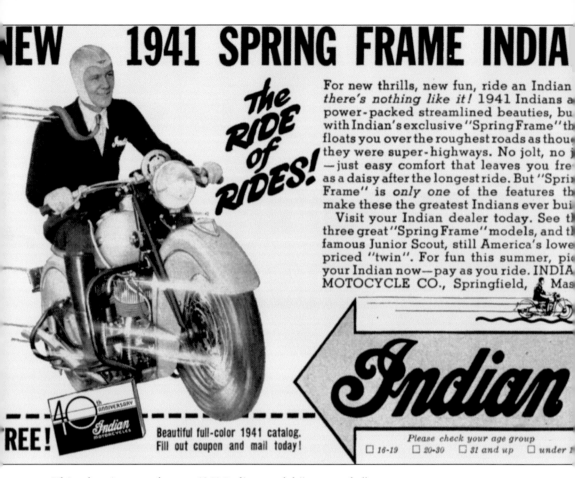

NEW 1941 SPRING FRAME INDIA

The RIDE of RIDES!

For new thrills, new fun, ride an Indian there's *nothing like it!* 1941 Indians a power-packed streamlined beauties, bu with Indian's exclusive "Spring Frame" th floats you over the roughest roads as thou they were super-highways. No jolt, no j —just easy comfort that leaves you fre as a daisy after the longest ride. But "Sprir Frame" is *only one* of the features th make these the greatest Indians ever bui

Visit your Indian dealer today. See th three great "Spring Frame" models, and th famous Junior Scout, still America's lowe priced "twin". For fun this summer, pi your Indian now—pay as you ride. INDIA MOTOCYCLE CO., Springfield, Mas

Indian

40th ANNIVERSARY Indian MOTORCYCLES

REE!

Beautiful full-color 1941 catalog.
Fill out coupon and mail today!

Please check your age group
☐ 16-19 ☐ 20-30 ☐ 31 and up ☐ under 1

This advertisement shows a 1941 Indian model "motocycle."

Five

THE GEM OF THE CITY

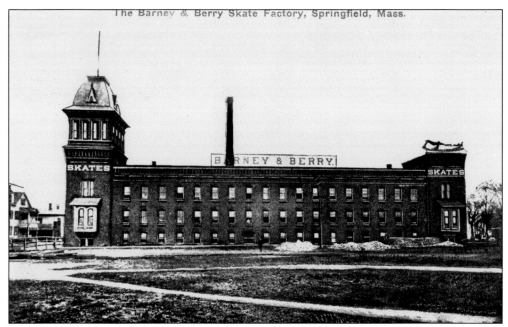

Forest Park, the city's large municipal park, was made possible through the generosity of several key Springfield residents, but primarily Everett Barney. Barney invented a clasp to attach ice skates and roller skates to shoes and made a fortune at his Springfield factory. (Courtesy of James Boone.)

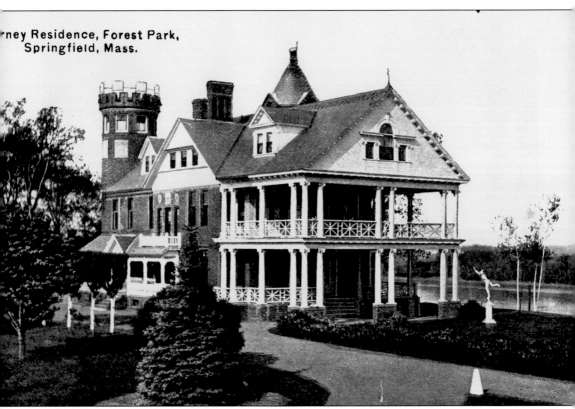

Everett Barney built a home, Pecousic Villa, in 1883 on a large estate near the Springfield and Longmeadow border. Some of his property was over the town line, and he successfully petitioned the legislation to have the border changed so all his property could be in Springfield.

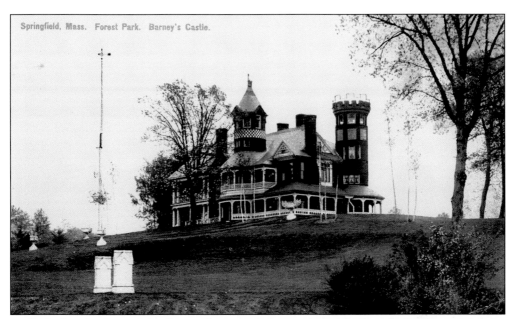

In 1883, the city formed the first parks commission, and Orrick Greenleaf presented the city with 70 acres for a city park. Two subsequent additions to Forest Park were then made. In 1890, Barney decided to give the city 109.5 acres of his property for the park. By 1906, the park was over 400 acres in size.

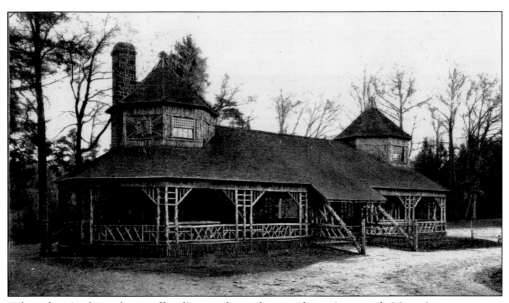

When the city brought a trolley line to the park, attendance increased. Many improvements, such as the building of the "rustic pavilion" in 1889, were made to the park property.

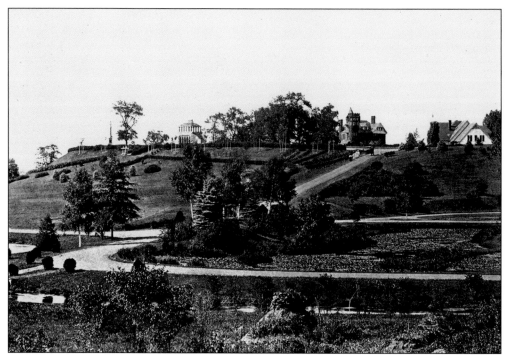

Much of the initial beauty of the park could be attributed to Everett Barney's elaborate grounds. He collected plants from around the world. The writer of a newspaper story from August 30, 1891, rhetorically posed the question of why farmers from Wilbraham and Agawam would come to Forest Park to enjoy the outdoors. The answer was "of course the natural beauties are here put on exhibition and are combined so as to produce the best effects."

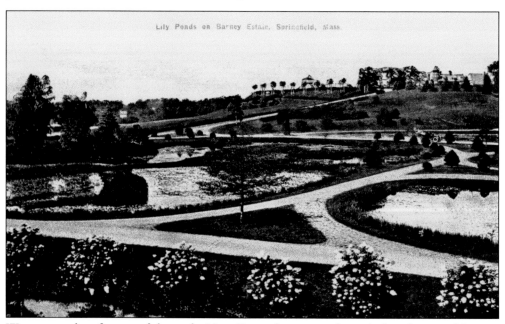

Water was a key feature of the park. Near Barney's estate, a fountain brook wound its way through the gardens in the valley.

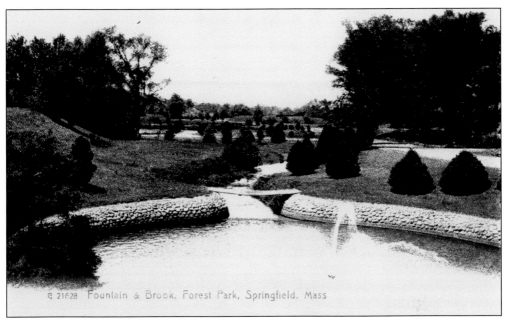

G 21628 Fountain & Brook, Forest Park, Springfield, Mass

Over the years, the fountain and falls were altered for a more dramatic effect.

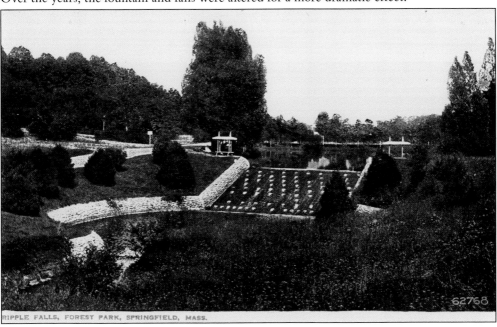

RIPPLE FALLS, FOREST PARK, SPRINGFIELD, MASS.

62768

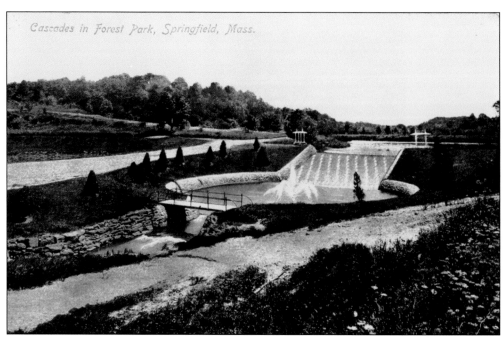

A bridge was added at one point over the brook. Today this area is filled with trees, giving the waterway a more natural look. The falls and fountain are still part of the park.

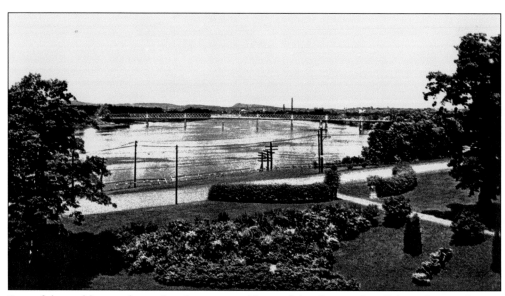

Part of the park's appeal was the vista one could see of the Connecticut River. Everett Barney had built his home at the top of a hill overlooking the river.

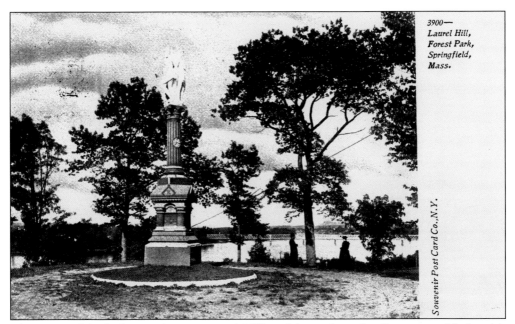

3900—
Laurel Hill,
Forest Park,
Springfield,
Mass.

Souvenir Post Card Co.,N.Y.

The name of the lookout point was Laurel Hill, and it was here that Barney would place his family mausoleum. Forest Park is probably one of the few public parks in America with a family grave site.

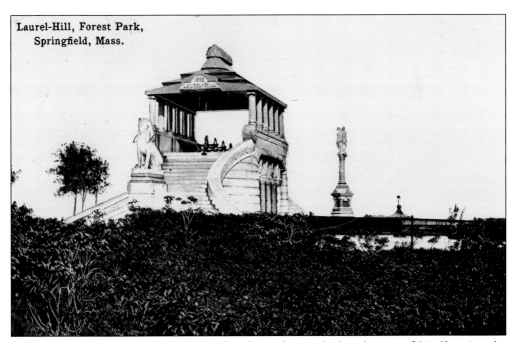

Laurel-Hill, Forest Park, Springfield, Mass.

Barney built the mausoleum in 1889 when his only son died at the age of 26. Showing the 19th-century interest in Egyptian design, the mausoleum is also the resting place of Barney and his wife. (Courtesy of Robert Walker.)

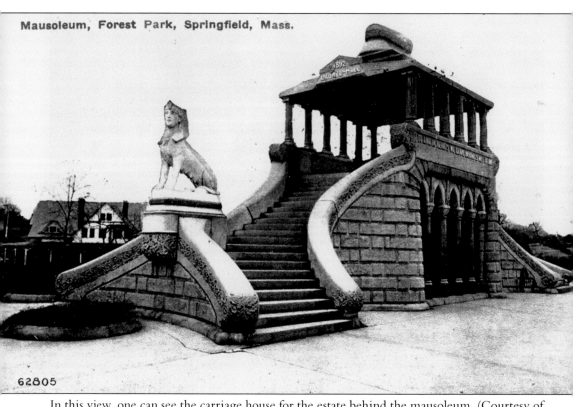

Mausoleum, Forest Park, Springfield, Mass.

62805

In this view, one can see the carriage house for the estate behind the mausoleum. (Courtesy of James Boone.)

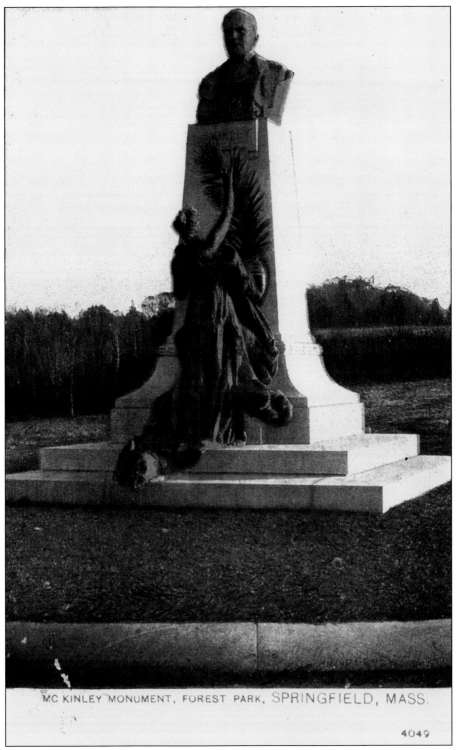

MC KINLEY MONUMENT, FOREST PARK, SPRINGFIELD, MASS.

4049

A monument was erected in the park to Pres. William McKinley, who was assassinated in 1896. The statue was moved to Court Square and is next to the Hampden County Courthouse.

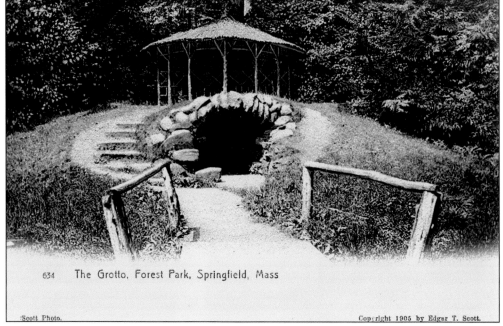

634 The Grotto, Forest Park, Springfield, Mass

While visitors may not realize that many aspects of the park have stayed the same over the last century, some things have changed. This grotto is no longer easy to find. (Courtesy of James Boone.)

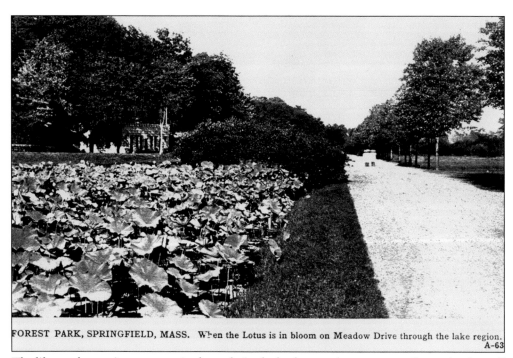

FOREST PARK, SPRINGFIELD, MASS. When the Lotus is in bloom on Meadow Drive through the lake region.
A-63

The lily ponds remain a constant in the park. In the background one can see a "warming house" for skaters. Skating on these bodies of water is no longer allowed.

Lake in Forest Park, Springfield, Mass.

Who fought the house — Apr 18 - 1905
a. G. n.

Published by Forbes and Wallace.

Forest Park mixed designed gardens with natural beauty, such as this wooded lake.

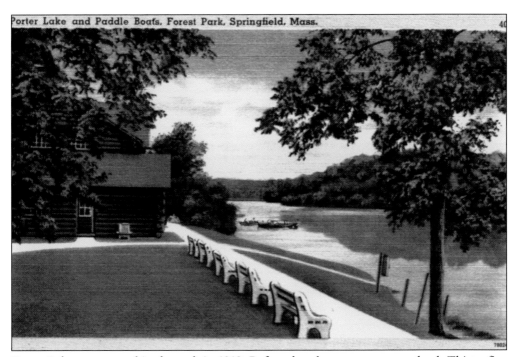

Porter Lake and Paddle Boats, Forest Park, Springfield, Mass.

Porter Lake was created in the park in 1919. Before that the area was pastureland. Thirty-five acres were added to the park and a dam was built in 1920. The lake was named after Sherman Porter, a benefactor to the park.

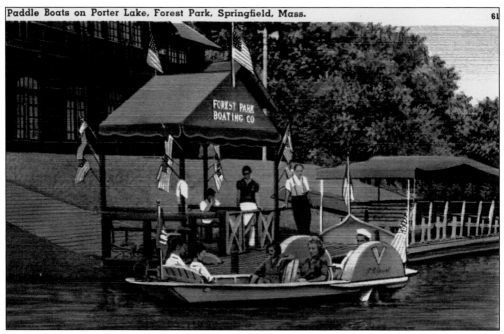

Paddleboats were a popular pastime on Porter Lake. (Courtesy of Robert Walker.)

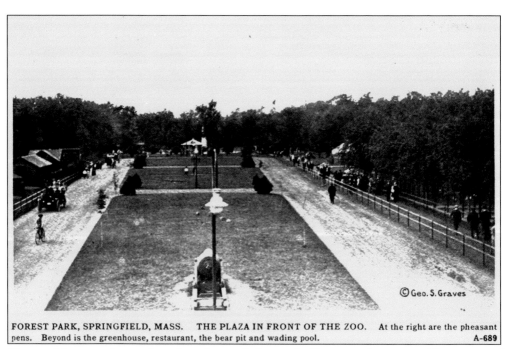

FOREST PARK, SPRINGFIELD, MASS. THE PLAZA IN FRONT OF THE ZOO. At the right are the pheasant pens. Beyond is the greenhouse, restaurant, the bear pit and wading pool. A-689

The park's central area has also changed dramatically over the years. (Courtesy of Robert Walker.)

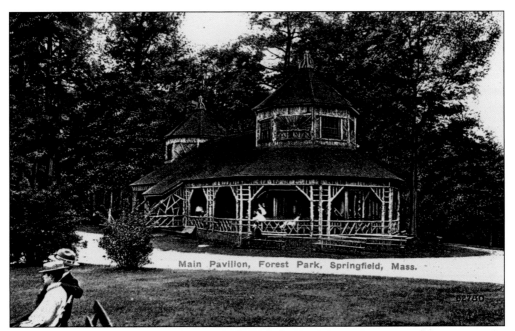

Main Pavilion, Forest Park, Springfield, Mass.

Although there is a pavilion at the Sumner Avenue entrance to the park today, it is not the original pavilion shown in these postcards. (Courtesy of Robert Walker.)

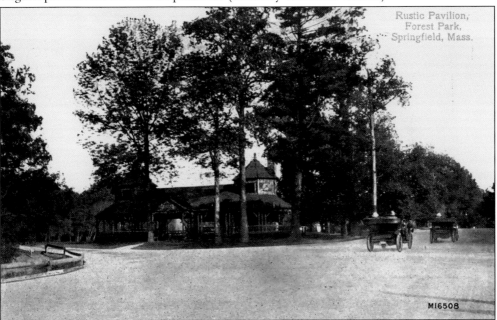

Rustic Pavilion, Forest Park, Springfield, Mass.

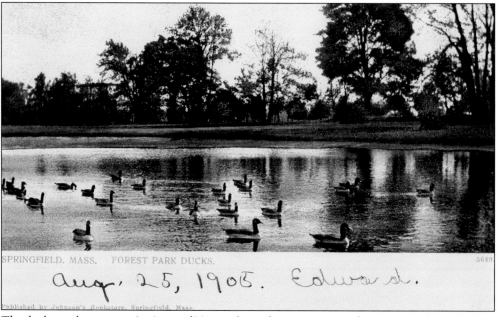

SPRINGFIELD. MASS. FOREST PARK DUCKS. 5649

Aug. 25, 1905. Edward.

Published by Johnson's Bookstore, Springfield, Mass.

The duck ponds are a continuing tradition at the park. Generations of visitors have brought bags of stale bread to feed the ducks and the geese.

Duck Pond, Forest Park, Springfield, Mass.

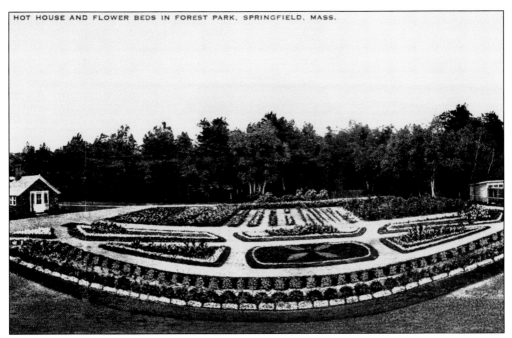

HOT HOUSE AND FLOWER BEDS IN FOREST PARK, SPRINGFIELD, MASS.

Continuing the interest in plants established by Everett Barney, for many years, the park management maintained gardens and a greenhouse.

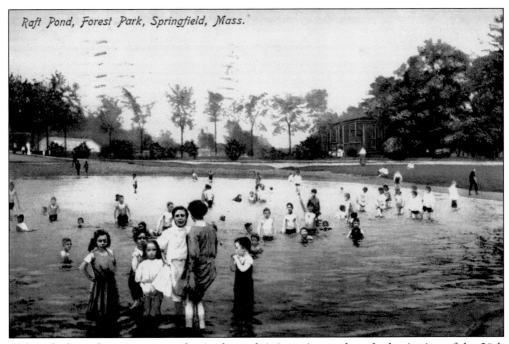

Raft Pond, Forest Park, Springfield, Mass.

Although the only swimming today in the park is in a city pool, at the beginning of the 20th century city, kids could cool off in this wading pool. (Courtesy of James Boone.)

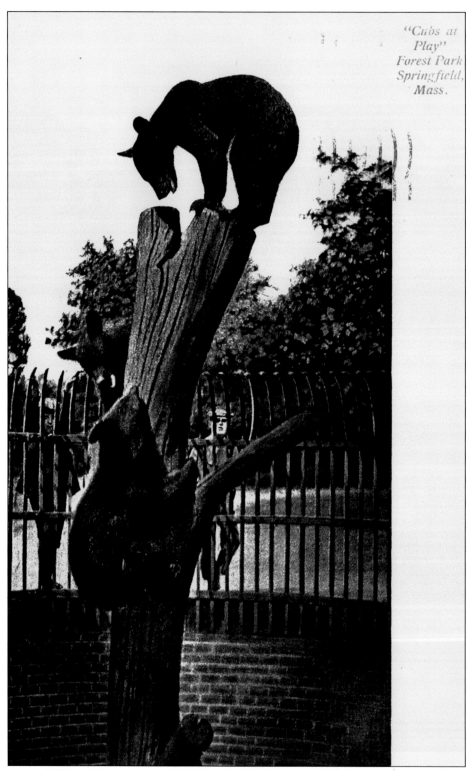

"Cubs at Play" Forest Park Springfield, Mass.

Animal exhibits, such as this one with bear cubs, became part of the park as early as 1906.

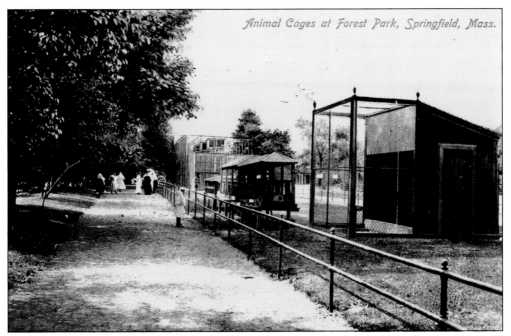

A zoo at the park was developed with small animal cages along a central walkway. (Courtesy of Robert Walker.)

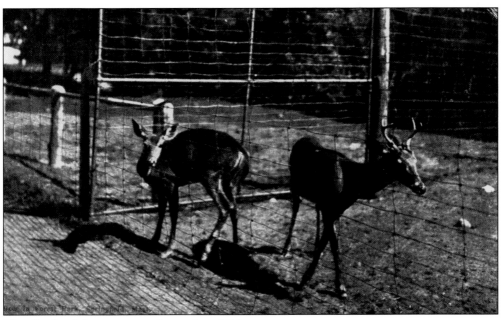

New England deer were another early exhibit.

FOREST PARK, SPRINGFIELD, MASS. AT THE ZOO. The exhibit here comprises over twenty species of animals and there are **130** specimens.
A-688

The small animal exhibitions grew into a large zoo. The brick buildings held the monkeys and larger animals such as lions. (Courtesy of Robert Walker.)

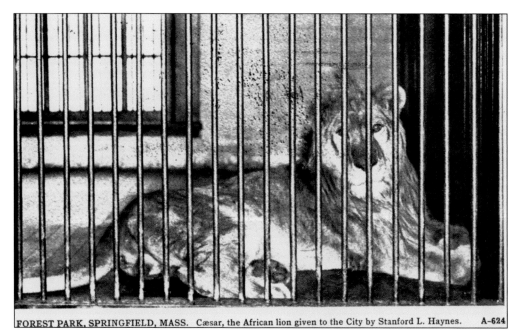

FOREST PARK, SPRINGFIELD, MASS. Cæsar, the African lion given to the City by Stanford L. Haynes. A-624

The city not only bought animals, but citizens made donations to add to the collection. (Courtesy of Robert Walker.)

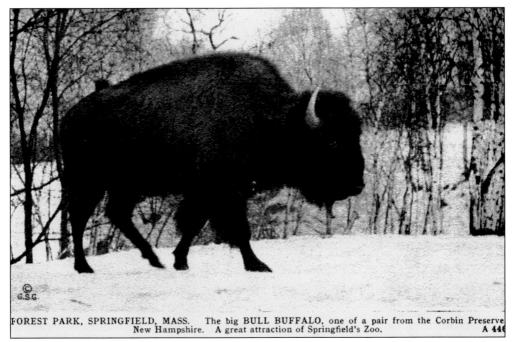

FOREST PARK, SPRINGFIELD, MASS. The big BULL BUFFALO, one of a pair from the Corbin Preserve New Hampshire. A great attraction of Springfield's Zoo. A 44€

The buffalo were part of the collection that, by 1934, had grown to 425 different animals from 15 countries. Although a popular attraction, by the 1970s, concerns over the cost of properly maintaining the zoo resulted in its closing in 1978. Today a small, privately run zoo rents space from the city in the park. (Courtesy of Robert Walker.)

Winter Scene in Forest Park, No. 8, Springfield, Mass.

As it was at the beginning of the 20th century, Forest Park remains a year-round attraction offering a place of quiet and nature in the middle of an urban center.

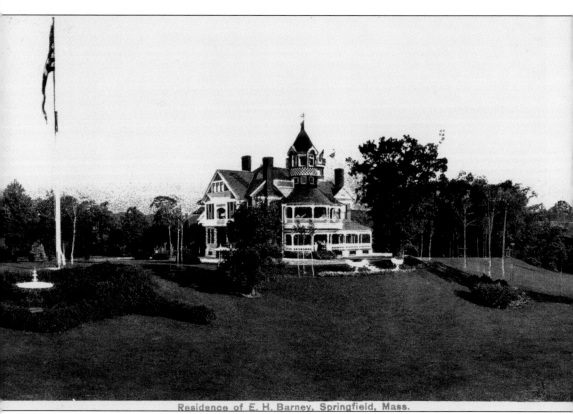

Residence of E. H. Barney, Springfield, Mass.

Everett Barney died in 1916, and his home was used by the city as the location for several museums as well as a venue for social events. In 1958, federal authorities announced the house was in the way of the exchange of U.S. Route 5 and the new Interstate 91. Although the city government and citizens tried to find a way to save the house by moving it 100 feet, the cost of over $150,000 and the feasibility of moving the structure prevented that action. In the spring of 1959, the house was demolished. The carriage house that remains was restored in the 1990s and is now used as a place for a variety of social functions.

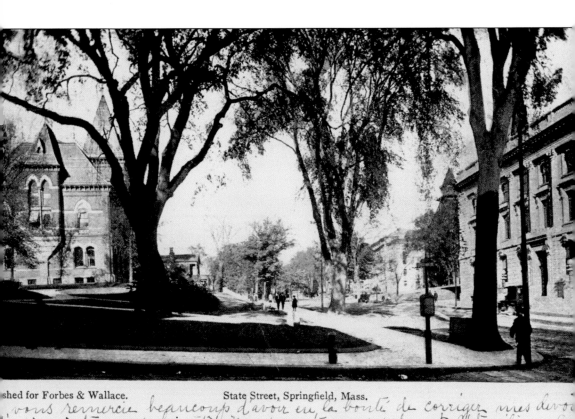

shed for Forbes & Wallace.

State Street, Springfield, Mass.

vous remercie beaucoup d'avoir eu la bonté de corriger mes devo... écrire, retourner bientôt. Mes parents vous saluent. Votre élève...

The phrase "everything old is new again" applies to the city of Springfield. As of 2008, a large project to restore State Street is under preparation. The goal is to improve the street's infrastructure, repair sidewalks, and plants trees, among other improvements. And while the city will never look as it once was, many people have dedicated themselves to saving the historic buildings and landmarks that still stand.

DISCOVER THOUSANDS OF LOCAL HISTORY BOOKS
FEATURING MILLIONS OF VINTAGE IMAGES

Arcadia Publishing, the leading local history publisher in the United States, is committed to making history accessible and meaningful through publishing books that celebrate and preserve the heritage of America's people and places.

Find more books like this at
www.arcadiapublishing.com

Search for your hometown history, your old stomping grounds, and even your favorite sports team.

Consistent with our mission to preserve history on a local level, this book was printed in South Carolina on American-made paper and manufactured entirely in the United States. Products carrying the accredited Forest Stewardship Council (FSC) label are printed on 100 percent FSC-certified paper.

MADE IN THE USA